DARTMOOR

From Old Photographs

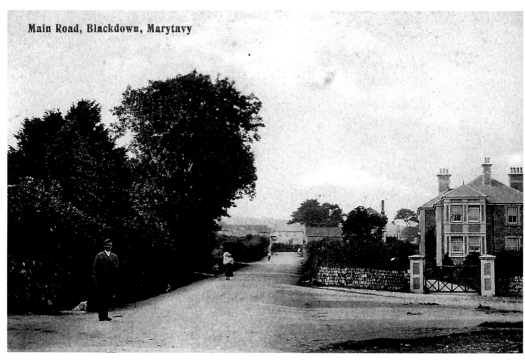

Main Road, Blackdown, Marytavy

The main road at Blackdown, Mary Tavy, *c.* 1900. This peaceful view of the village gives no indication that at the time, the name was synonymous with mining on Dartmoor.

DARTMOOR

From Old Photographs

John Van der Kiste

JOHN VAN DER KISTE

AMBERLEY

First published 2010

Amberley Publishing Plc
Cirencester Road, Chalford,
Stroud, Gloucestershire, GL6 8PE

www.amberley-books.com

British Library Cataloguing in Publication Data.
A catalogue record for this book is available from the British Library.

ISBN 978 1 84868 731 8

Typeset in 10pt on 12pt Sabon.
Typesetting and Origination by Amberley Publishing.
Printed in the UK.

Contents

Introduction

The history of Dartmoor can be loosely traced back to several centuries BC. Most of its surviving prehistoric remains are thought to date back to the late Neolithic and early Bronze Age, and it has the largest concentration of Bronze Age remains in Britain. Much of the moor covers a plateau of granite, a very durable igneous rock which has ensured the survival of remains of so many buildings, enclosures and monuments, including standing stones or longstones, kistvaens or tombs, and stone circles. Several thousand hut circles remain, albeit depleted after being raided over the years for dry stone walls. Some ancient structures, notably hut circles at Grimspound, were reconstructed during the Victorian era by enthusiasts such as the engineer and historian Richard Hansford Worth.

In prehistoric times the climate was milder, and much of the land was covered with trees until settlers began clearing them to establish the first farming communities Controlled burning was used to clear the land and create pasture for cultivation or grazing sheep and cattle. Over the centuries such practices greatly expanded the upland moors, contributing to the acidification of the soil and the accumulation of peat and bogs. When the climate worsened around 1000 BC, much of high Dartmoor was abandoned. Over the next few centuries it became a largely 'unclaimed' area, though still used in summer for grazing livestock.

Some centuries later it became a hunting ground for the Kings of Wessex. After the Norman conquest of England in 1066, it was declared a royal forest, with all deer, boars and wolves being declared the sovereign's property, and foresters appointed to oversee the land. At the time much of it was covered by oak trees, though subsequent farming and small settlements gradually reduced the woodland cover. This gradually helped to shape vast expanses of what is considered the traditional moorland landscape of gorse and heather, interspersed with tors, deep valleys and rivers.

In the twelfth century King John afforested the whole of Devon. This was bitterly resented, and after a petition of 1204 it was agreed that in return for payment of a large sum, the King would grant a charter disafforesting the county 'up to the metes [boundaries] of the ancient regards of Dartmoor and Exmoor'. In 1239 King Henry III granted his brother Richard, Earl of Cornwall, the Forest of Dartmoor and the Manor of Lydford. Dartmoor was no longer a 'forest' and became a 'chase', though the name 'forest' has remained, particularly on maps, to the present. On Richard's death, his son Edmund succeeded him as Earl of Cornwall. He died childless in 1300, and the Forest and Manor both reverted to the crown. In 1337 King Edward III granted these lands to his son Edward, Prince of Wales and Duke of Cornwall. Ever since then the Forest has belonged to the Duchy of Cornwall.

Settlers moved on to the moor from the thirteenth century onwards. While prehistoric farmers had lived in granite roundhouses located within small settlements, or pounds, their medieval successors built longhouses, oblong buildings which housed farmers and their livestock. Some have been abandoned and only the ruins remain, but about 130 are still standing. A few are still used as farm buildings, while others have become private homes, bed and breakfast establishments, and a few have even been turned into hotels.

Though obviously regarded as part of the countryside, Dartmoor has a resident population estimated at about 33,000. In terms of population, the largest towns are Ashburton, Buckfastleigh, Moretonhampstead, Princetown and Yelverton. Princetown, regarded unofficially as the archetypal Dartmoor town, is roughly in the centre of the moor, and is the highest above sea level. It was built in the late seventeenth century by Sir Thomas Tyrwhitt, secretary to George Prince of Wales, later King Regent and King George IV, and named 'Prince's Town', in his honour. In 1806 Tyrwhitt laid the foundation stone for the prison, built chiefly to hold prisoners of the Napoleonic wars.

Soon afterwards, it became a convenient training ground for the army. A large military camp was established at Okehampton, which also became the site of an airbase during the Second World War. Since then the Ministry of Defence has continued to use certain areas of the northern moor for manoeuvres and live-firing exercises.

In October 1951, two years after the passing of the National Parks and Access to the Countryside Act, Dartmoor was officially designated a National Park, confirming its recognition as 'an extensive area of beautiful and relatively wild country in which for the nation's benefit and by appropriate national decision and action' its characteristic landscape beauty should be strictly preserved, access and facilities for public open air enjoyment amply provided, wildlife, buildings and places of architectural and historic interest suitably protected, and established farming use effectively maintained. Over half of Dartmoor National Park is private land, much of it owned by the Duke of Cornwall. About one-eighth is owned by the Ministry of Defence, with smaller areas also belonging to water companies, the National Trust, the Forestry Commission and Dartmoor's National Park Authority.

Dartmoor's various industries have also left their traces on the landscape. Tin mining in the area, thought to date back to Roman times if not earlier, continued until the closure of Golden Dagger mine, near Princetown, in 1930. The last iron mine in the area, Great Rock Mine, near Bovey Tracey, closed in 1969, and the last remaining granite quarry, Merrivale, in 1997. Extensive conifer plantations have been created, providing employment but proving detrimental to the moorland and resulting in the loss of several archaeological sites, including a prehistoric stone circle near Fernworthy.

The moor has long been a source of water. From the mid-nineteenth century onwards, eight reservoirs were built to serve the needs of Devon's cities and towns. The first, at Tottiford, near Bovey Tracey, was completed in 1861, and the last was at Meldon in 1972.

The area is rich in legend. Headless horsemen, pixies, a large black dog and a mysterious pack of hounds all have their place in local myths and legends, as does a visit said to have been made by the devil to Widecombe in 1638 during a fierce

thunderstorm. From the 1920s, tales have persisted of motorists and campers being threatened by the 'hairy hands', on the B3212 road near Two Bridges, with at least one fatal accident as a result. It has also provided a home and inspiration to several writers over the years, including Sir Arthur Conan Doyle, Eden Phillpotts, Beatrice Chase, Agatha Christie, John Galsworthy, and the Revd Sabine Baring-Gould.

The photographs which follow span the era from the late nineteenth century to the mid twentieth century. They have been chosen to show the diversity of the landscape, the major towns and villages, and the different uses made of Dartmoor as a source of local employment and industry as well as a haven for wildlife and recreation. At the same time I hope they convey something of the beauty and spirit of an area which I have been fortunate to know and live near for most of my life.

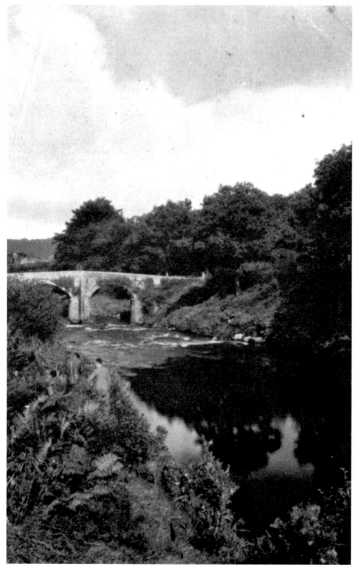

Newbridge, over the River Dart, which gives the moor its name. Built around 1413 from local granite with three semi-circular arches, it is on the road between Ashburton and Two Bridges, a favourite spot for riverside walkers, canoeists and kayakers.

CHAPTER ONE
Views

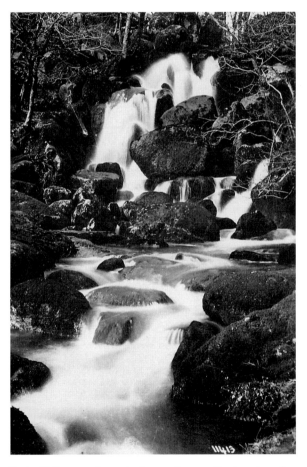

Becky Falls, now the main focus of a woodland park and popular tourist attraction, in the steep wooded valley near Manaton.

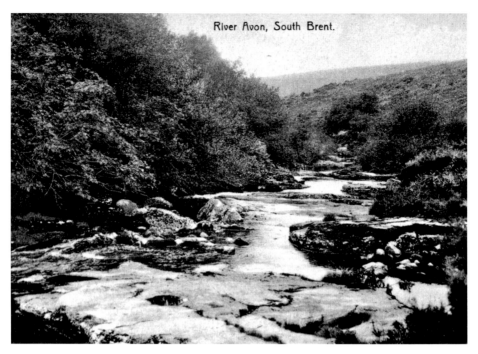

The Avon, near Shipley Bridge, alongside the path that leads to the Avon Dam.

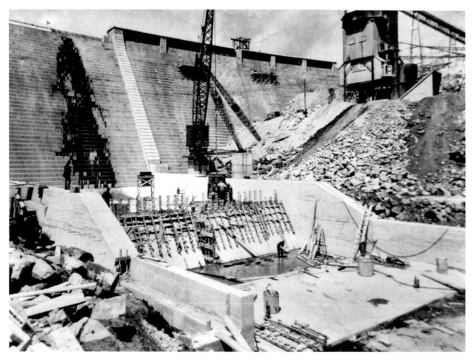

The Avon Dam, while under construction, c. 1956. Completed the following year, it is at the end of a public footpath from Shipley Bridge, near South Brent.

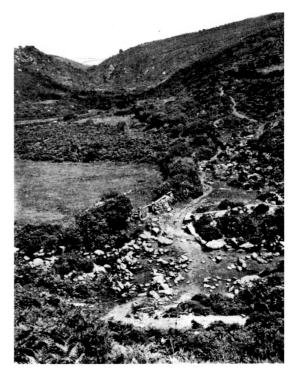

Belstone Cleave, a steep wooded valley near Belstone village, close to the northern boundary of the moor, through which the Taw runs.

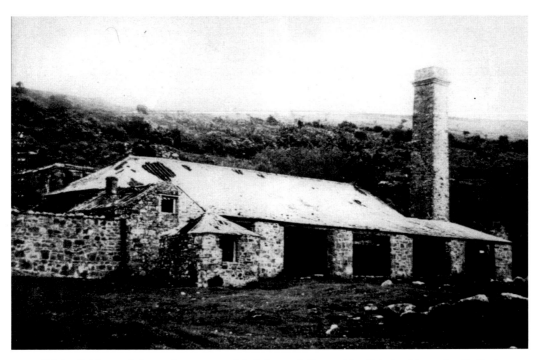

Shipley Bridge naphtha works, c. 1900. Naphtha, an inflammable oil derived from the distillation of peat, was used in making gas and candles, at works opened by L. H. Davy and William Wilkin of Totnes in the mid nineteenth century.

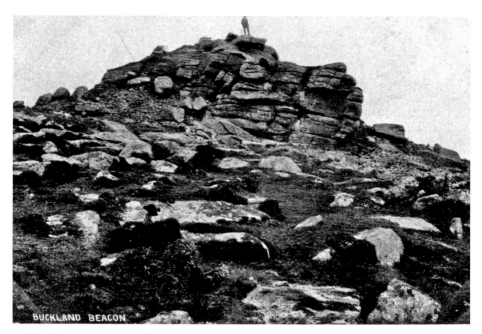

Buckland Beacon was one of the beacons used to warn of the arrival of the Spanish Armada off the coast in 1588, and since then has often been lit to celebrate royal jubilees and the millennium in 1999.

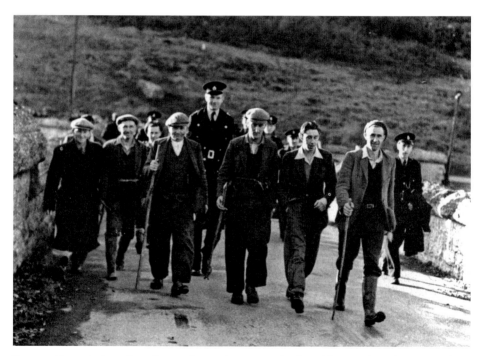

Burrator Dam, during a hunt by warders and watermen in the mid 1950s for prisoners on the run from Princetown Gaol.

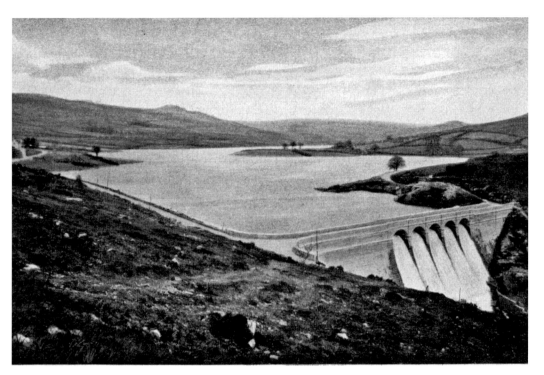

Two views of Burrator, from postcards published *c.* 1910. The first shows the reservoir, completed in 1898 as Plymouth's main water supply, while the second shows what was at the time referred to as 'the lake', with Peak Hill, Leather Tor and Sharp Tor. Burrator was completely frozen over in January 1917 with ice ten inches thick on top, but this did not prevent water from still being delivered to Plymouth.

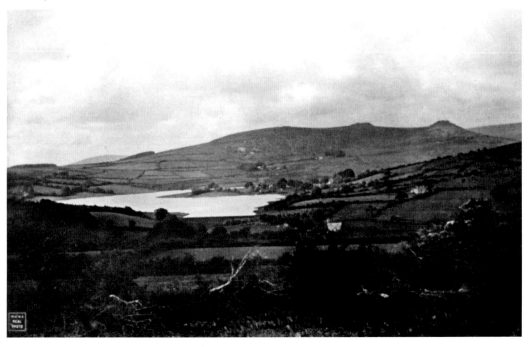

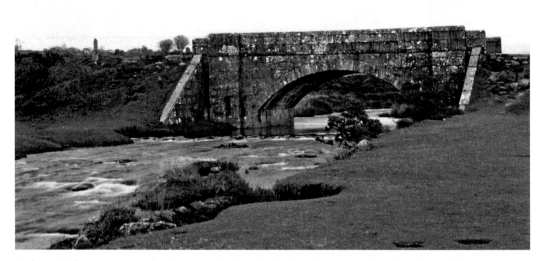

Cadover Bridge, *c.* 1913, is also known as Cadworthy Bridge. On the southern boundary of the moor, near Shaugh Prior, it crosses the junction of the Plym and Meavy rivers.

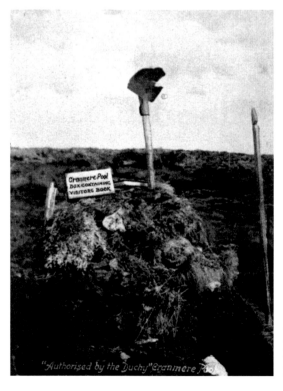

Cranmere Pool, from an Edwardian postcard, showing a box containing the visitors' book from which the hobby of letterboxing later developed.

Two views of Cherrybrook, one of the brooks which feeds the West Dart. The first is probably taken from Higher Cherrybrook Bridge *c.* 1933, showing the old farmhouse since converted into a hotel. The second shows Cherrybrook and Bellever Tor. Surrounded by coniferous forests, Bellever is rich in the remains of old settlements and stone rows, while the tor overlooks the valleys of the East and West Dart on their approach to Dartmeet.

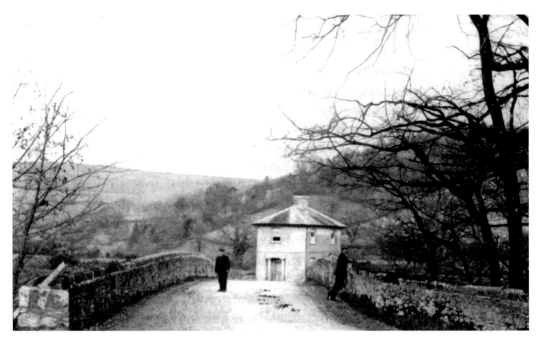

The Dart Bridge, between Ashburton and Buckfastleigh, *c.* 1905. It was widened in 1929, and the tollhouse was demolished when the A38 was built about forty years later.

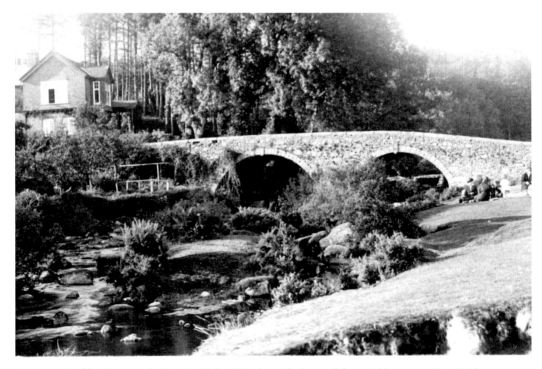

A three-arched bridge over the Dart in Holne Woods, with the road from Ashburton to Two Bridges rising up steeply from here up Newbridge Hill to Poundsgate.

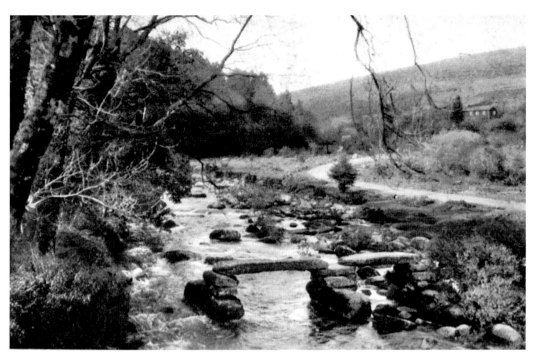

Dartmeet medieval clapper bridge over the East Dart, and the drive to Badgers Holt, formerly a fishing lodge and now a restaurant. The bridge was washed away by floods in 1826, but restored in 1888 by the Dartmoor Preservation Association.

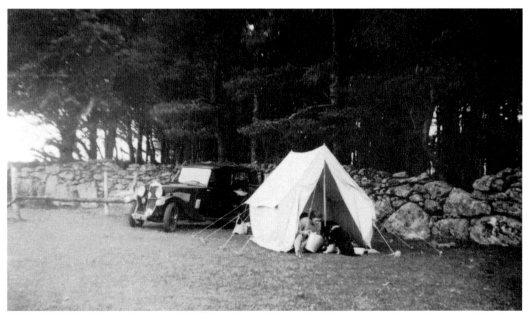

The wall near Dunnabridge Pound Farm, showing several of the Holman family (including the present author's mother) as they put up a tent to camp one night in the summer of 1938. The dog came too.

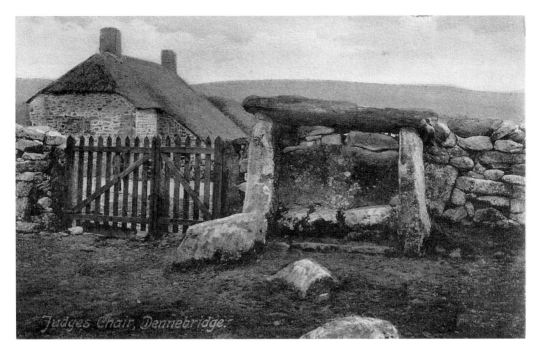

The Judge's Chair, or Brown Berry chair, at Brown Berry Farm, now demolished, at Dunnabridge Farm, near Two Bridges. The seat is said to be made up from the stannary court judge's chair, and the canopy from the stannator's table. Its purpose was to provide shelter for the pound keeper, who oversaw animals driven to the pound following the drifts (rounding up of livestock illegally depastured on Dartmoor), and collected outstanding fines from their owners.

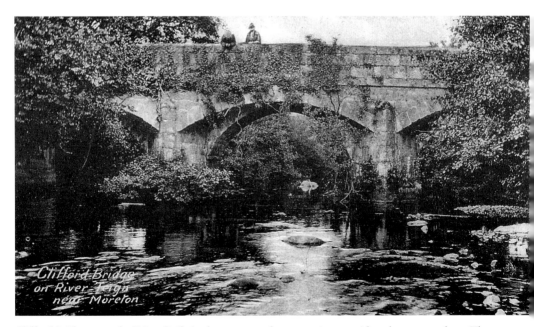

Clifford Bridge, over the Teign. Built in the seventeenth century, it was widened 200 years later. The Teign forms a boundary between the parishes of Dunsford and Moretonhampstead.

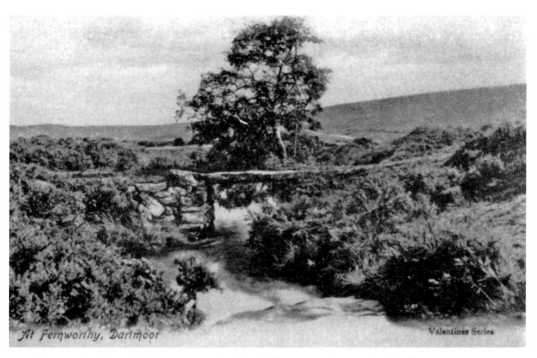

Fernworthy clapper bridge, spanning the South Teign, now submerged under the reservoir.

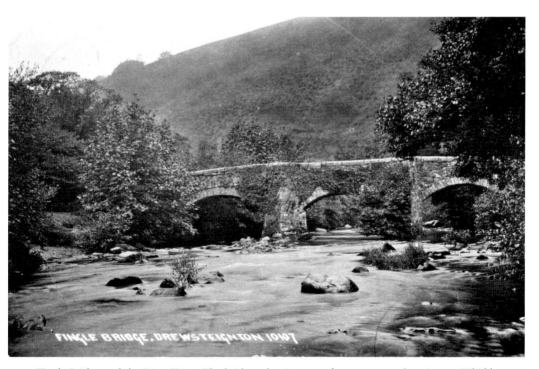

Fingle Bridge and the River Teign. The bridge takes its name from a stream that rises on Whiddon Down and descends to join the Teign.

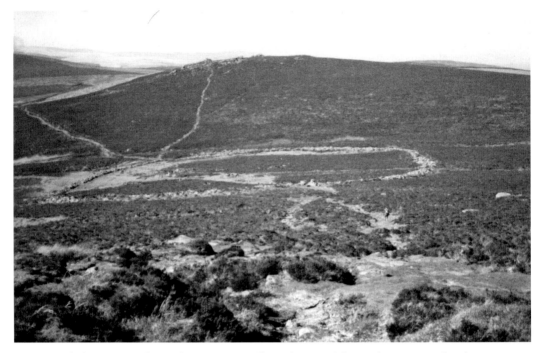

Grimspound, the remains of an early Bronze Age village, the central feature being a pound enclosing twenty-four huts.

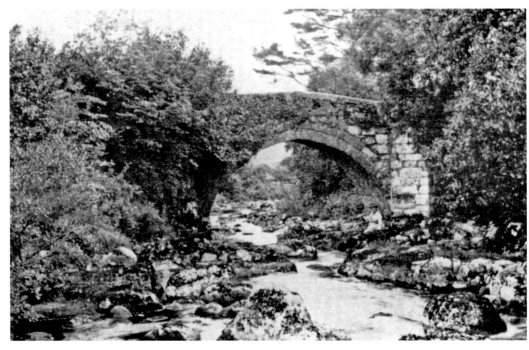

Harford Bridge, *c.* 1900, a narrow stone bridge near the southern edge of the moor, crossing over the Erme.

Harford from Hanger Down, an area long noted for its striking circular copse of trees, visible from a considerable distance.

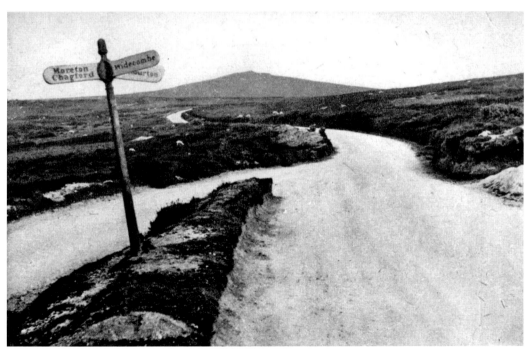

Harefoot Cross, c. 1925, a junction on the road between Ashburton and Widecombe, with Rippon Tor in the background.

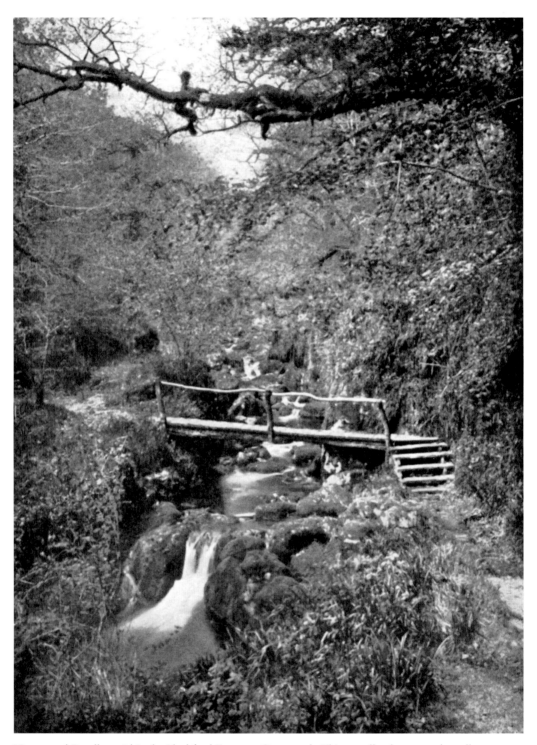

Hawns and Dendles, within the Blachford Estate at Cornwood. This woodland runs up the valley, between the River Yealm and the Broadall Gulf. The name probably comes from a Madam Hawns and the Dendles (or Daniels) family who owned property there.

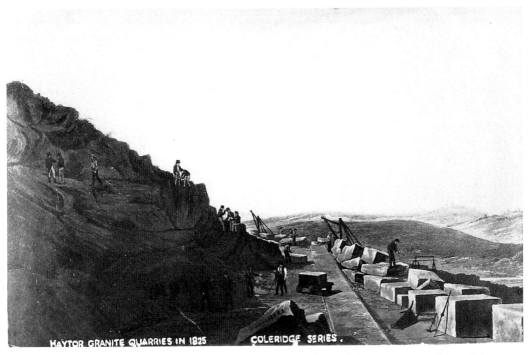

Two postcards of Haytor Quarries, one with a picture of the workforce *c.* 1825, and one of the disused quarries *c.* 1930, hardly unchanged today. The quarries were opened in 1820, and the granite, taken along the granite-railed tramway to the Stover Canal at Ventiford, Teigngrace, then to Teignmouth for export by ship, was used in building the British Museum and London Bridge. They were closed about 1860 as they could not compete with the cheaper Cornish stone, though granite was still occasionally extracted, the last occasion being for the Exeter War Memorial in 1919.

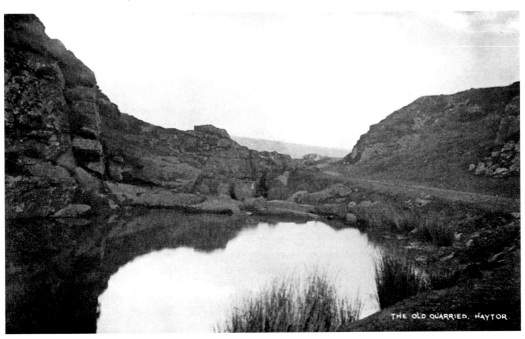

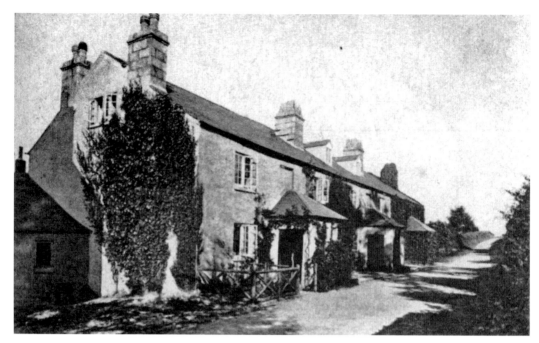

Haytor Vale Cottages, *c.* 1910, built in 1825 as accommodation for the quarry workers.

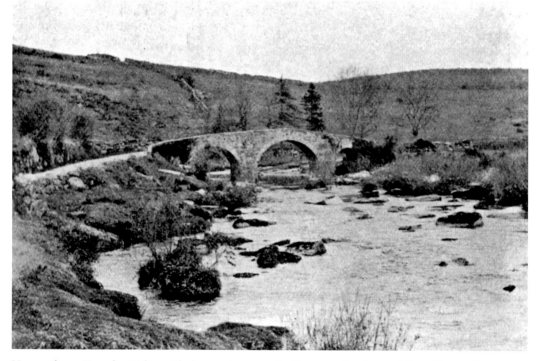

Hexworthy or Huccaby Bridge, with three arches over the Dart, carrying the road from Hexworthy over West Dart to join the B3357 between Two Bridges and Ashburton.

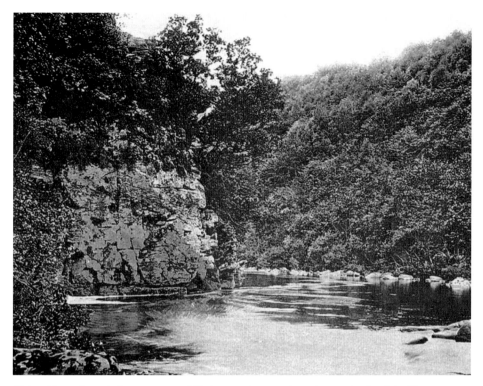

Holne Chase, Lover's Leap, a steep cliff above a deep pool on the east bank of the Dart.

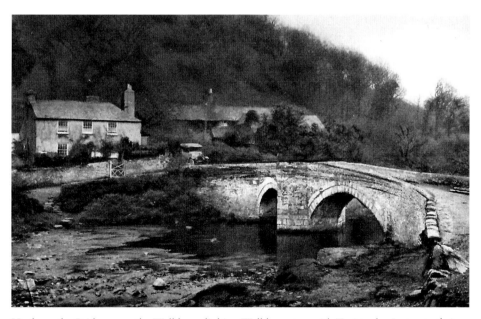

Huckworthy Bridge, over the Walkham, linking Walkhampton with Tavistock. Just out of view on the right is Huckworthy Mill, once powered by a leat from the river and now a private residence. The bridge is featured in Edith Holden's *Country Diary of an Edwardian Lady*.

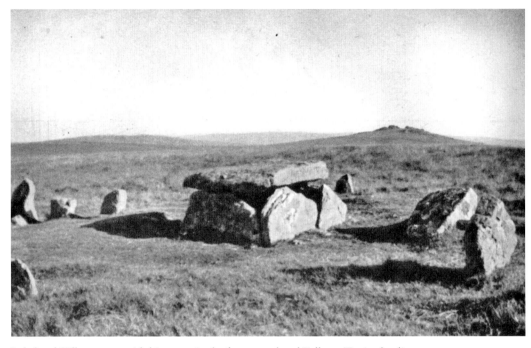

Lakehead Hill, *c.* 1930, with kistvaens in the foreground and Bellever Tor in the distance.

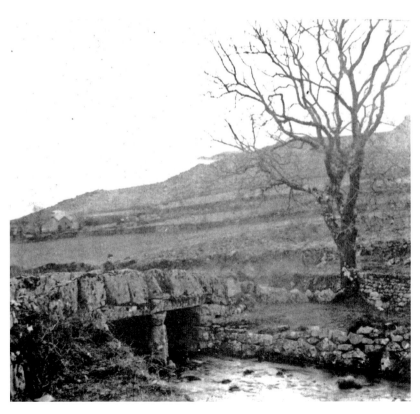

Leather Tor clapper bridge, on a bridleway which crosses the River Meavy.

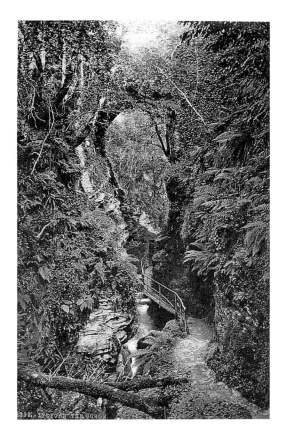

Lydford Gorge, the deepest gorge in the west
country, stretches for a distance of about one
and a half miles, from the Devil's Cauldron
whirlpool at one end to the White Lady
waterfall at the other.

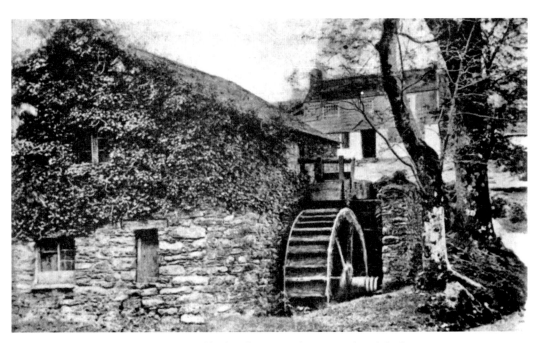

An old mill and waterwheel at Lydford Mill, *c.* 1900, long since demolished.

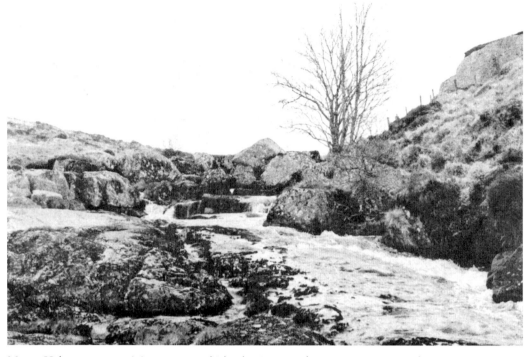

Manga Hole, *c.* 1900, a miniature gorge which takes its name from Manga Farm nearby.

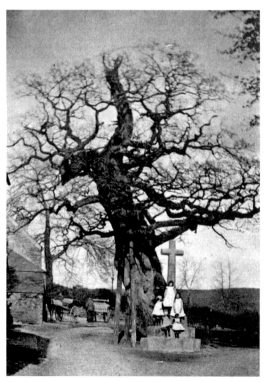

Meavy Oak, said to have been planted in the twelfth century when St Peter's Church was first built, though others believe that it is older still.

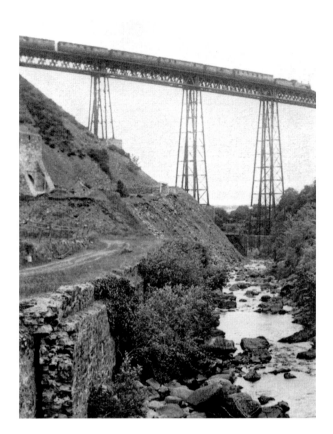

Two views of Meldon Valley. The first, *c.* 1906, shows the viaduct which was built in 1874 over the West Okement River and widened four years later. The upper part of the valley now contains Meldon Reservoir, completed and opened in 1972, the last to be built on the moor.

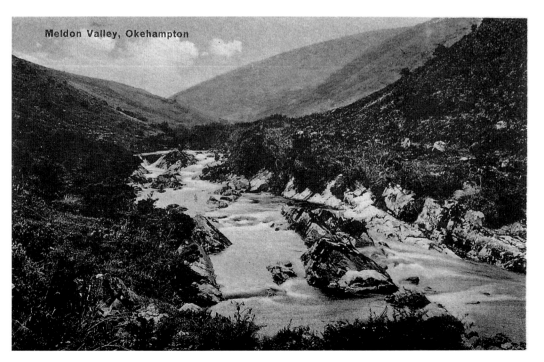

Meldon Valley, Okehampton

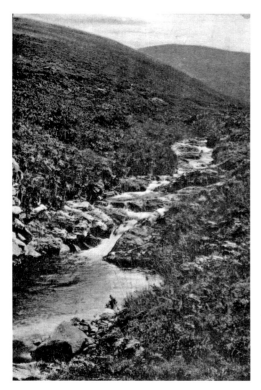

The West Okement and Yes Tor. The Okement, formerly the Ock, a tributary of the Torridge, rises at two places on the moor as the West and East Okement which meet other small streams and join at Okehampton.

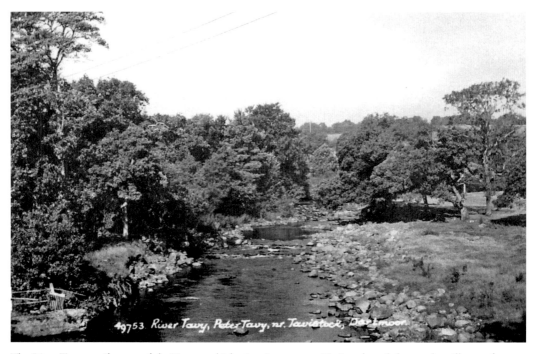

The River Tavy, a tributary of the Tamar, which gives its name to Tavistock and the nearby villages of Peter Tavy and Mary Tavy.

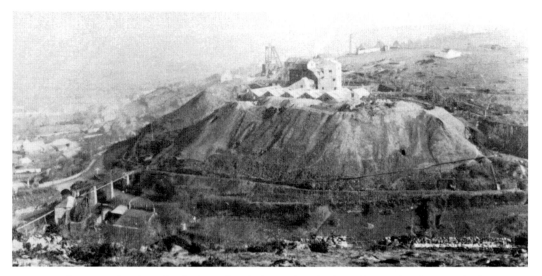

Ramsley Mine, South Zeal, which employed about a hundred people in its heyday, was the last mine in England which produced exclusively copper. It closed in 1909.

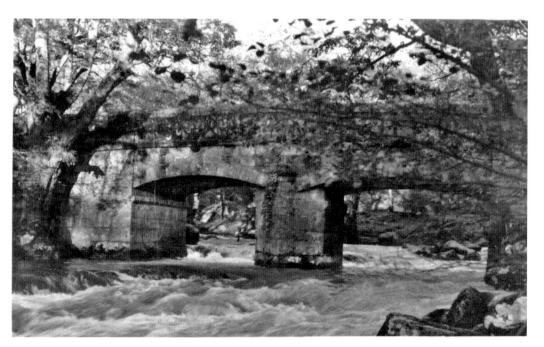

Shaugh Prior Bridge, between the villages of Shaugh Prior and Bickleigh. The original bridge was washed away by severe flooding in 1823.

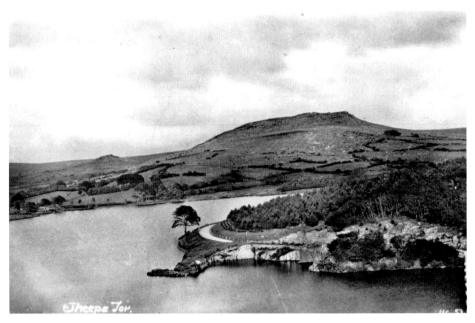

Sheepstor from a distance. The village is named after the outcrop about half a mile north-east.

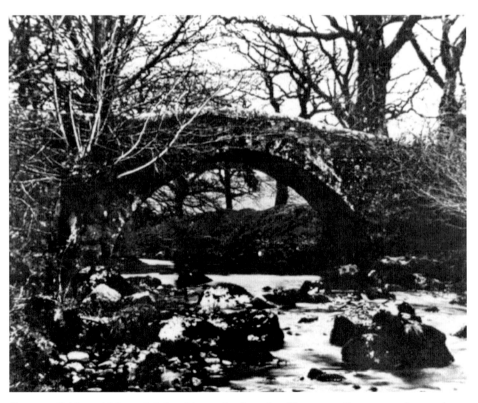

Sheepstor Bridge, which carried the old moorland road to Sheepstor village, was submerged when Burrator Reservoir was completed in 1898.

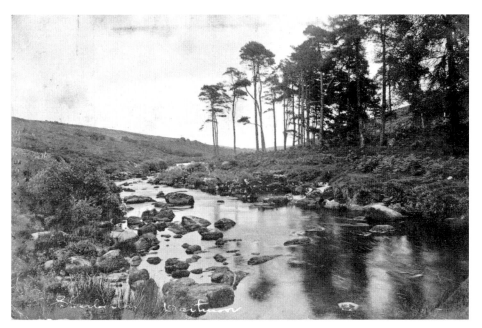

Sherberton Firs, *c.* 1910, the wooded river scene near Sherberton Farm, one of the ancient tenements where settlers within Dartmoor Forest during medieval times were allowed to build farms and release their livestock on surrounding land.

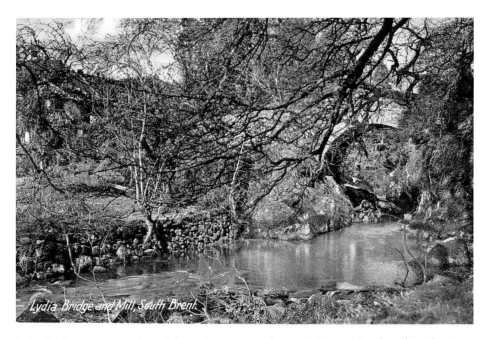

Lydia Bridge, a seventeenth or eighteenth century packhorse bridge on the edge of South Brent over the Avon. The county surveyor's sign to owners, drivers and persons in charge of locomotives that it 'is insufficient to carry weights beyond the ordinary traffic of the district', and that they cannot cross without official permission, is still on the side.

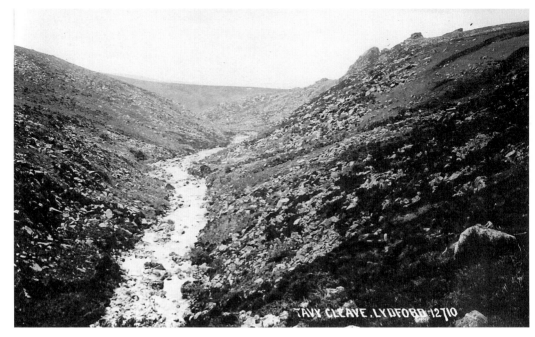

Tavy Cleave, a steep sided river valley characterised by granite rock clitter on each side of the steep slopes, a cleave being a steep river valley cut through by the water.

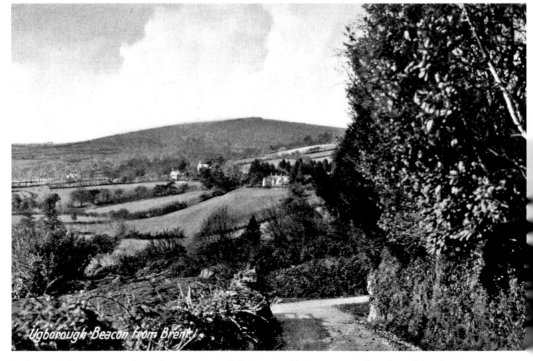

Ugborough Beacon, seen from the junction uphill from Oakhill Cross, on the edge of South Brent, *c.* 1940.

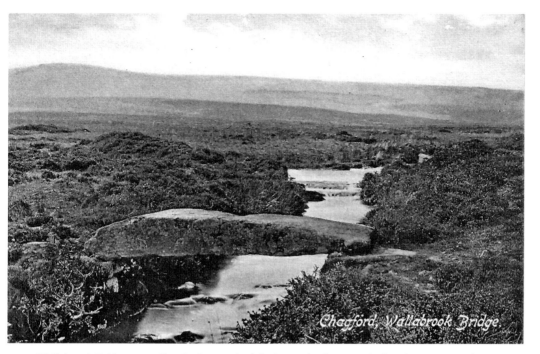

Wallabrook Bridge, near Chagford, a single slab clapper bridge over the brook, sometimes known locally as the Headon river, just before it joins the North Teign. The area was once regularly worked by the tin miners, and the bridge was probably built in Elizabethan times, if not earlier.

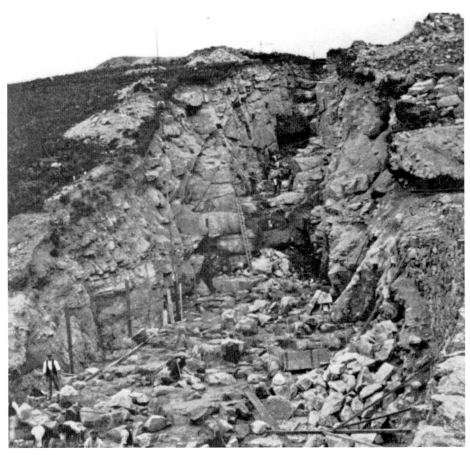

Venford Reservoir, formerly known as Paignton Waterworks, which covers 33 acres. In 1901 the estimated cost was £27,583, but by the time of completion in 1907 it had risen to £119,697. These two pictures show it while under construction in 1904, and shortly after its opening.

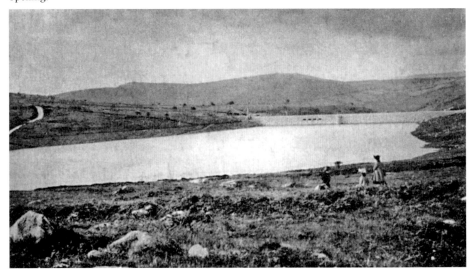

CHAPTER TWO

Tors, Crosses, and Stones

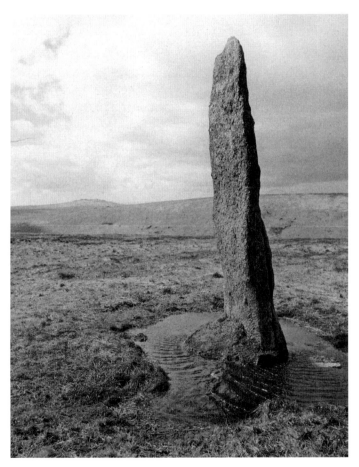

Beardown Man, north of Princetown. Thought to date from the
Bronze age, at 11 ft high it is the tallest menhir or standing granite
stone on the moor.

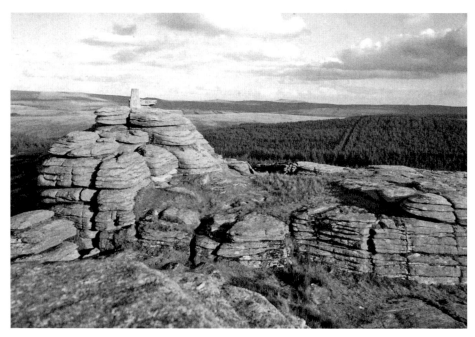

Bellever Tor, looking towards the east with Bellever Forest behind, and Hameldown, Haytor and Rippon Tor just visible on the horizon.

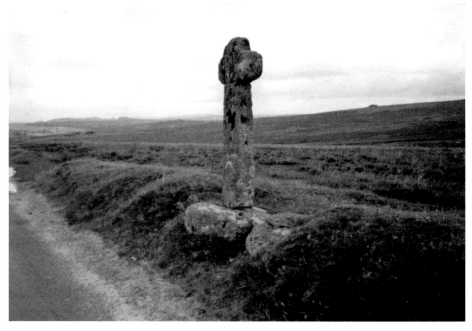

Blackaton Cross, or Roman's Cross, near Shaugh Prior and Cadover Bridge, is a waymarker on the route to Plympton Priory. The first name refers to the Blackaton Slaggets nearby, an area once extensively used for cutting peat, while St Roman or St Rumon was one of the saints to whom Tavistock Abbey is dedicated.

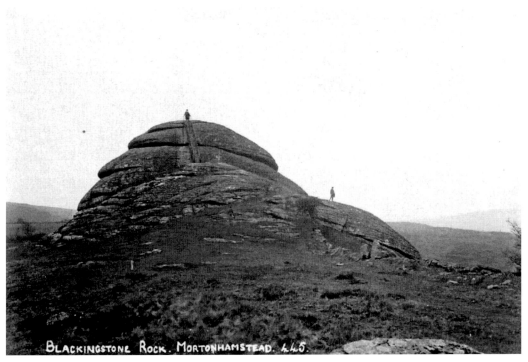

Blackingstone Rock, near Moretonhampstead. The steps and railings added in the nineteenth century to allow walkers access and views from the top, are clearly visible. Granite from the quarry nearby was used in the construction of Castle Drogo.

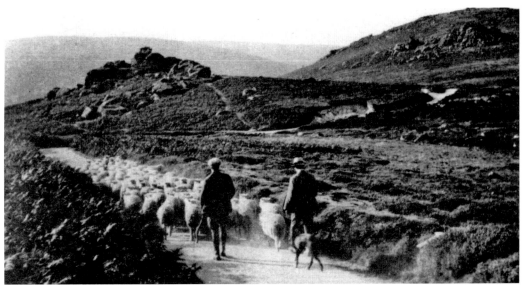

Bonehill Rocks, north-east of Widecombe, road with Bel Tor and Chinkwell Tor to right, Hameldown in distance, *c.* 1920, particularly loved by children of all ages for the many small rocks, caves and tunnels. Views across the valley to Widecombe-in-the-moor are wonderful.

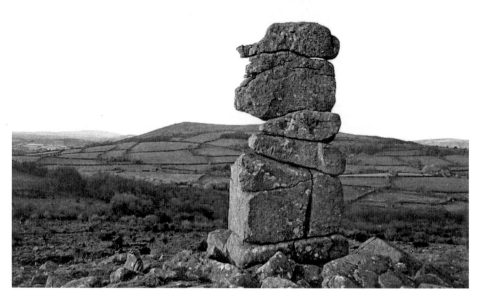

Bowerman's Nose, near Manaton. Over 21 ft high, this is one of the moor's most striking landmarks. It is said to take its name from the legendary huntsman Bowerman who was out with his hounds chasing a hare, a witch in disguise. While leading him up the hillside near Manaton, she swung round, turning him and his hounds into stone.

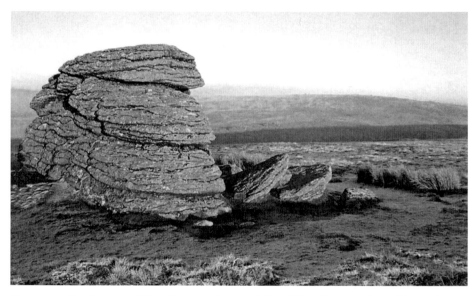

Branscombe Loaf, near the West Okement, is named after Walter Branscombe, a thirteenth-century Bishop of Exeter, who was riding home with his chaplain when the devil appeared, offering them some bread and cheese. As the Bishop reached out for it, the chaplain saw the devil's cloven hoofs underneath his coat and swept the food away. He disappeared, leaving a whiff of sulphur and two outcrops of rocks where the food had landed. To this day, they are known as Branscombe's loaf and cheese.

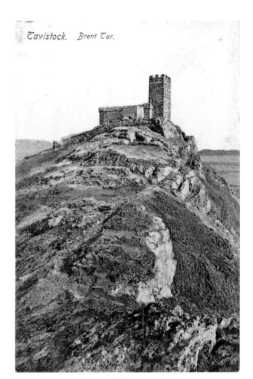

Tavistock. Brent Tor.

Brentor, about 1130ft above sea level. It is dominated by the thirteenth-century church of St Michael de Rupe, said to be built by a merchant who was saved from shipwreck during a storm and vowed to erect a church on the highest land he saw on his return.

Broadall Lake is a tributary of the river Yealm, and on the west side is a prehistoric settlement with pounds, reaves, hut circles and a field system. This image shows the remains of a tinner's hut nearby.

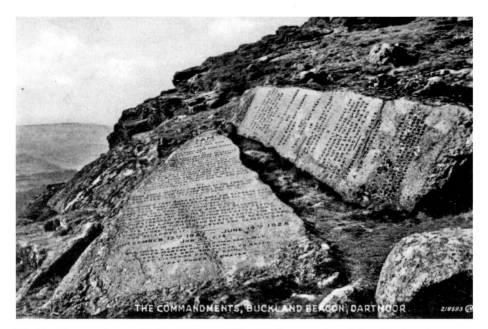

The Ten Commandments, Buckland Beacon. When Parliament rejected the adoption of a new proposed Book of Common Prayer in 1928, the then Lord of Buckland Manor, hailing it as 'a triumph of Protestantism over Popery', commissioned an Exmouth stonemason to engrave the commandments on two tablets of stone on the beacon. The stones were recut in 1995 by the Dartmoor National Park Authority.

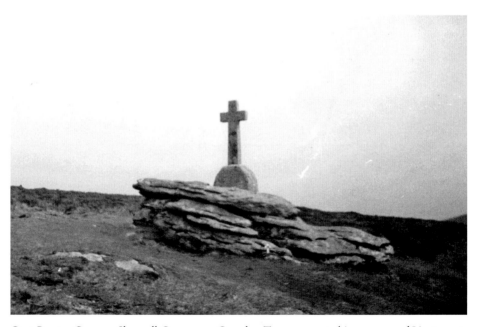

Cave-Penney Cross or Sherwell Cross, near Corndon Tor, was erected in memory of Lieutenant Anthony Cave-Penney, killed in action in Palestine, June 1918, at the age of nineteen. Affixed to a large boulder, it stands at an altitude of about 1,300ft.

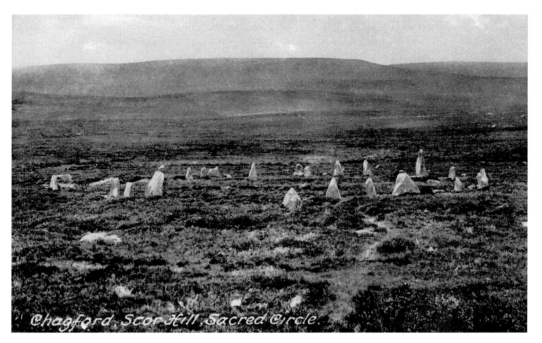

Scorhill Sacred Circle, Gidleigh Common, near Chagford. Sometimes known as Gidleigh Circle, it is considered one of the finest moor stone circles, with twenty-three standing granite and eleven fallen stones. It was once thought to comprise about seventy standing stones and would have been the largest such structure on Dartmoor.

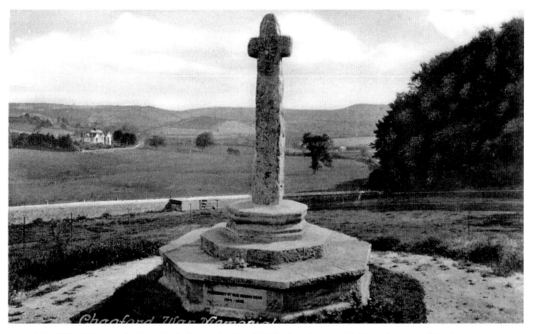

The War Memorial, Chagford, formerly the old Market Cross which used to stand in the town square but is now in the grounds of the fifteenth-century Church of St Michael.

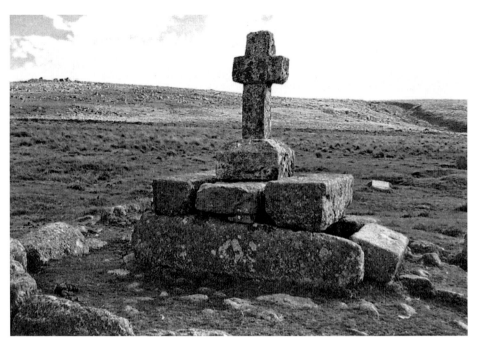

Childe's Tomb. Legend has it that the tomb of Childe of Plymstock was hunting on the moor when he got lost in a storm, killed his horse, cut it open and climbed inside to keep warm. Destroyed in 1812 and restored in 1885 by the Dartmoor Preservation Association, it stands on the edge of Foxtor Mires.

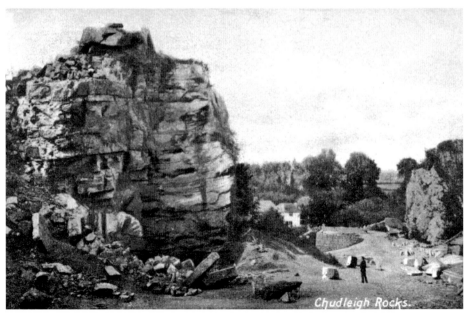

Chudleigh Rocks is a limestone outcrop to the south-west of the town. It includes a rock called the Pope's Head, which is supposed to bring you luck if you stick a pin in it and it does not fall out. (Assuming you can get the pin in...)

Combestone Tor, about 1938. Regarded as one of the most accessible of Dartmoor tors because of its proximity to a car park, it has outstanding views of the Dart valley.

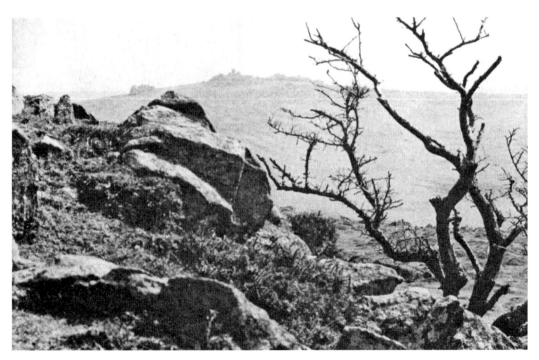

Cox Tor, near Tavistock, has long been a favourite destination for walkers with its commanding views to the west, encompassing as far as Plymouth Sound and east Cornwall.

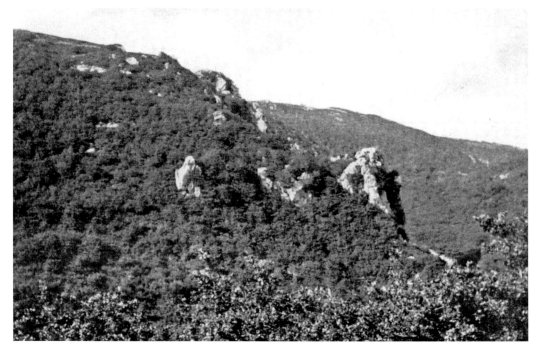

The Dewer Stone, a huge crag near Shaugh Prior, is named after Dewer, a legendary Huntsman said to be Satan in disguise, terrorising the moor at night with his pack of phantom hounds. The crag, thought to have once been home to a golden eagle eyrie, is sometimes known as Eagle's Rock.

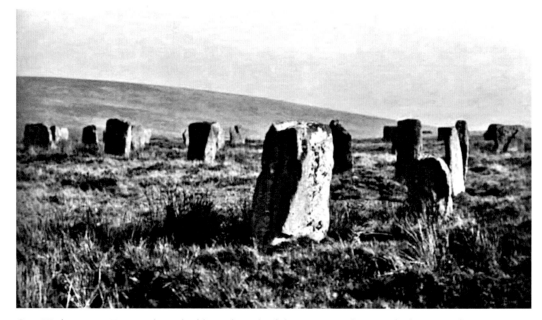

Grey Wethers, near Fernworthy, a double circle each of thirty stones, photographed prior to their restoration by Burnard in 1909. Each circle has a diameter of 33 metres, aligned almost exactly north and south of each other.

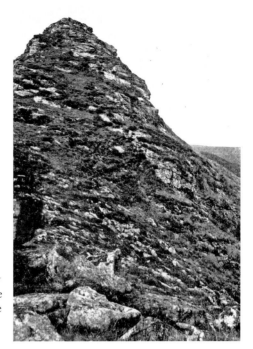

Ger Tor, about 1350ft above sea level. Described by William Crossing, *Gems in a Granite Setting*, as 'the hoary crest of Nat Tor Down' and 'the great granite bosom', it provides a spectacular view above Tavy Cleave.

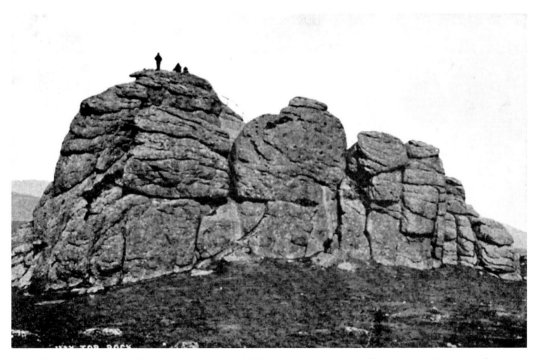

Haytor Rocks, 1500ft high, comprise one of the moor's most visited beauty spots. In 1851, after steps were cut into one side on the Tor, and a metal handrail was fixed to allow easier access to the top, an observer complained that it had been defaced 'to enable the enervated and pinguitudinous scions of humanity of this wonderful nineteenth century to gain its summit'.

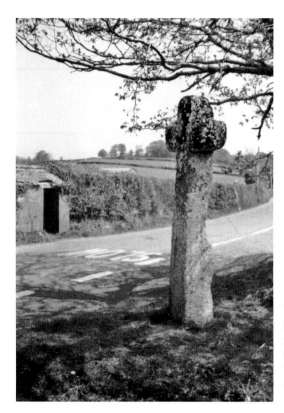

Hawson Cross, and the 'stumpy oak', at Scorriton Crossroads, near Holne, is the first cross on the Monk's Path, an ancient trackway which links Buckfast Abbey with Tavistock and Buckland Abbeys. It was restored by the Dartmoor Preservation in 1952.

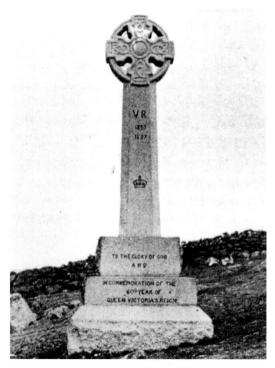

Hexworthy Jubilee Cross, a Celtic cross across the road from the Forest Inn overlooking the Dart Valley erected for Queen Victoria's Diamond Jubilee in 1897.

Hobajohns Cross, a standing stone on Ugborough Moor, forms part of a stone row from Piles Hill to Butterdon Hill. This is a replacement for the original, which was removed to nearby Three Barrows *c.* 1550, probably as a marker for an ancient pathway across the moor.

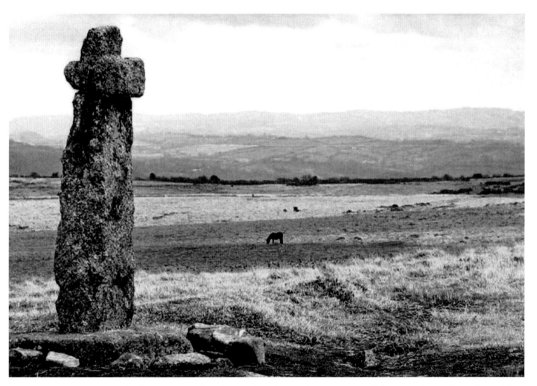

Horn's Cross, on the lower part of Holne Ridge, lies at the junction of the Monks' Path and an old farming track from South Brent to Hexworthy. In the late nineteenth century it was found to be badly damaged and was extensively restored with a new shaft.

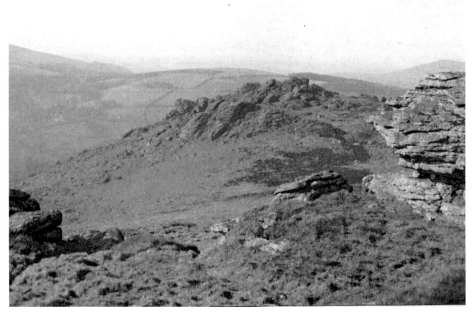

Honeybag Tor from Chinkwell, near Widecombe, *c.* 1940. Natsworthy Tor and Heathercombe Valley are to the left.

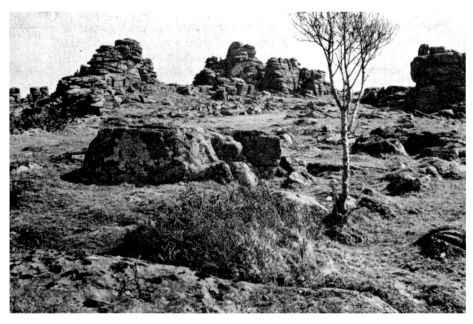

Hound Tor, close to the B3387 between Bovey Tracey and Widecombe, was named after the shape of the blocks on the summit which is thought to resemble the heads of dogs looking over the battlements. Nearby are the remains of a deserted medieval village, thought to have been abandoned around 1350.

Hunts Tor, in the Teign Valley, notable for the rocks which form an impressive river gorge towards Dunsford Bridge.

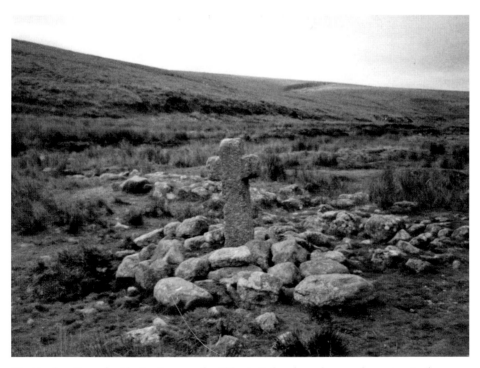

Huntingdon Cross, beside the Avon on the Abbot's Path, a boundary marker set up in the sixteenth century by the Petre family of Brent Manor to determine the extent of their new estate that came into their possession after the dissolution of Buckfast Abbey.

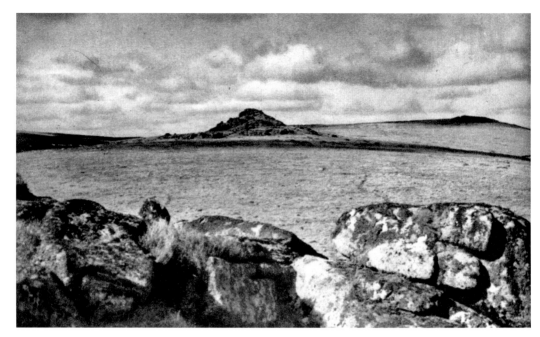

Longaford Tor, *c.* 1930, with Higher White Tor from the Littaford Tors.

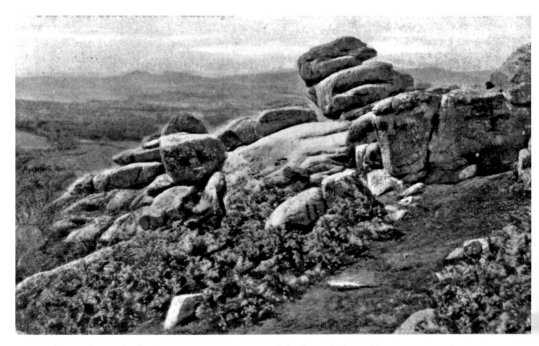

Nutcracker Rock, Lustleigh Cleave, *c.* 1906, was one of the finest balanced logan stones (a logan or logging stone is one that through natural weathering has been left balanced on top of another rock). In 1950 it was completely dislodged from its base, probably by vandals, and thrown on to a ledge below. A contingent of soldiers from Plymouth was sent on 'Operation Nutcracker' with lifting gear to restore it, but failed.

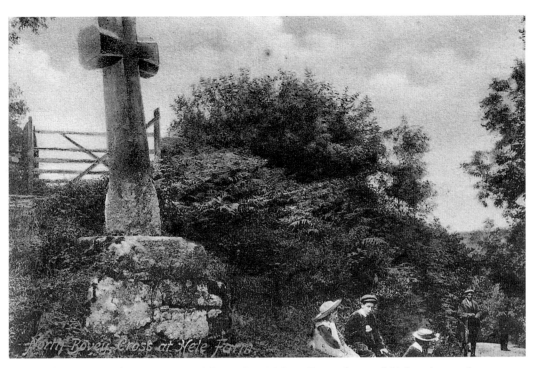

Hele Cross, North Bovey, *c.* 1908. This ancient Maltese Cross, almost 6ft high and over 2ft across the arms, is at the junction next to Hele Farm, on the road between North Bovey and Chagford. The shaft is set into a stone socket square and chamfered into an octagon at the top. It was thought to belong to a chapel at the bottom of the hill beside the stream, and people gathered round it to pray for a safe journey before walking to Tavistock Abbey.

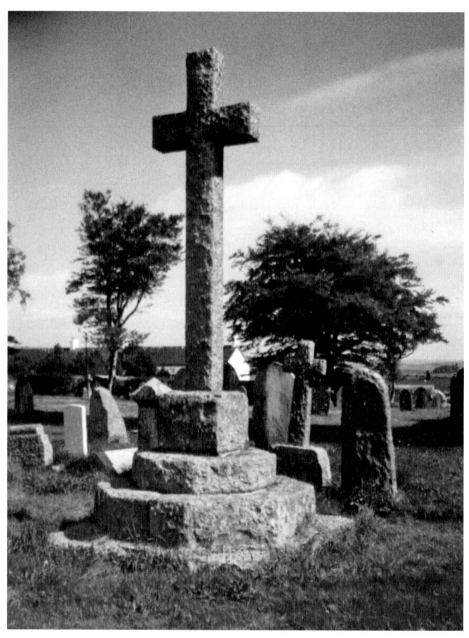

A large cross in the churchyard of St Michael and All Angels, Princetown, 10ft high and 3ft 6in across the arms, erected in 1912 as a memorial for prison inmates buried in unmarked graves. The church was built in 1814 by the French and American prisoners of war, who were paid *6d* per day.

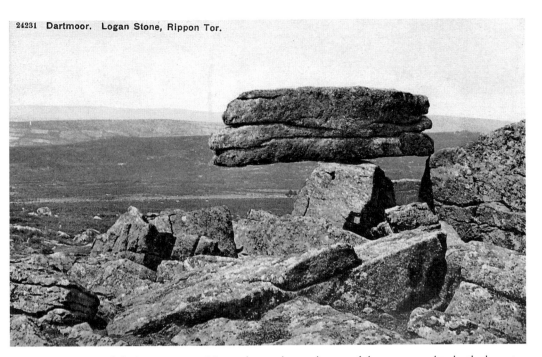

Rippon Tor and the logan stone or Nutcracker to the south-west of the tor, reputed to be the largest logan stone on the moor.

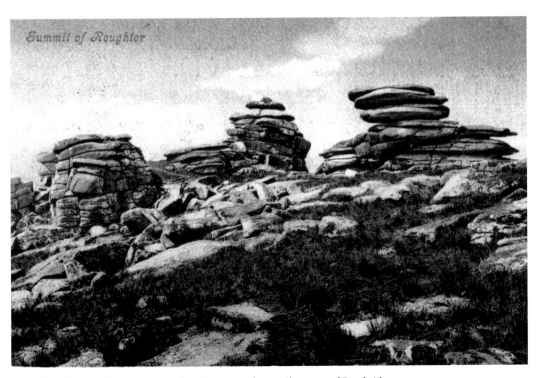

Summit of Roughtor

Roughtor, or Rowtor, above the West Dart, three miles west of Postbridge.

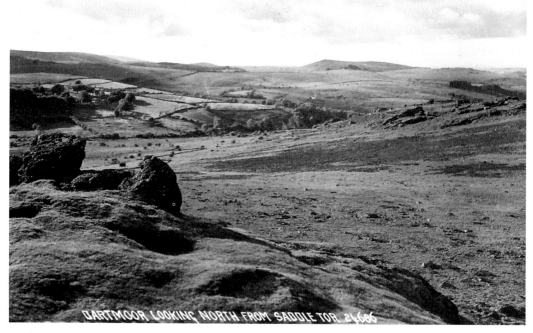

Saddle Tor, near Haytor, named thus because of the two main granite outcrops separated by an open clear grassy area.

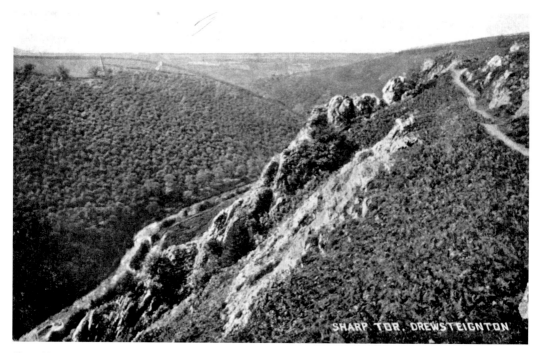

Sharp Tor, near Drewsteignton, a tor consisting of two rocky outcrops on the northern slope of the Teign valley.

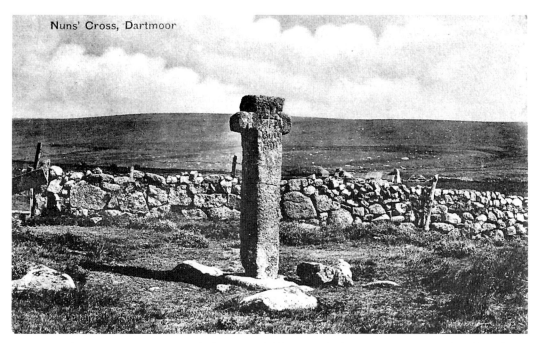

Nuns' Cross, Dartmoor

Siward's Cross, or Nuns' Cross, the largest and oldest recorded cross on the moor, is thought to have been erected in the eleventh century. Named after Siward, Earl of Northumbria, Lord of the Manor of Tavei (probably Mary Tavy), it stands at the junction of the Monks' Path and the Abbots' Way, which link Buckfast Abbey to Tavistock Abbey and Buckland Abbey.

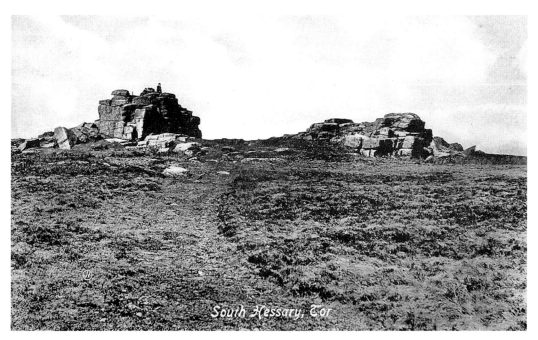

South Hessary, Tor

South Hessary Tor, 1490ft high, sometimes called South Hisworthy Tor, was also known as Lookout Tor, as a stone and timber lookout tower was built on the ridge during the Napoleonic Wars.

Spurrels Cross, near Harford, on Piles Hill, at the junction of tracks from Owley Moor Gate to Harford and Wrangaton to Erme Pound. 5 ft 6 in tall, it has only one remaining arm. It was restored to its current position by Dartmoor Preservation Society in the 1930s and given a new shaft.

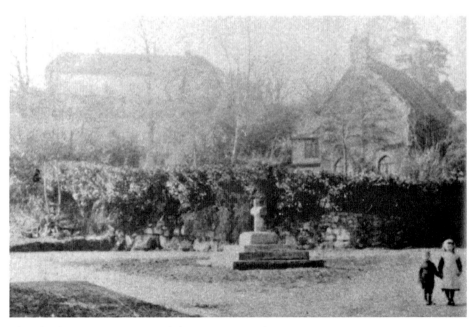

Throwleigh Barton Cross, near Okehampton, restored in 1897 to commemorate Queen Victoria's Diamond Jubilee.

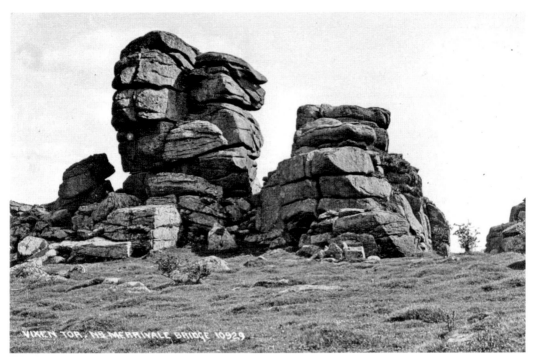

Vixen Tor, sometimes called 'the sphinx of Dartmoor', named after the wicked witch Vixana who used to live there and lure unwary travellers into the bogs nearby. At the time of writing, it stands on private land.

Wacka Tor, west of Hickley Plain, near South Brent, one of the moor's less conspicuous tors, consisting of four scattered piles.

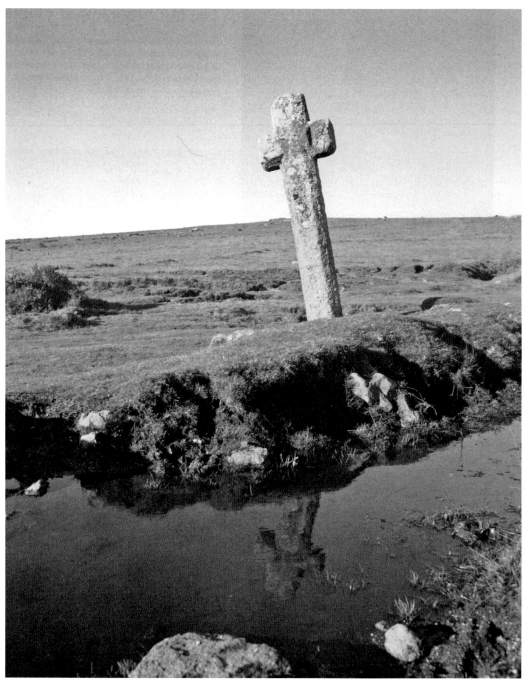

Windypost Cross, or Beckamoor Cross on the slopes of Whitchurch Common overlooking the Walkham Valley, adjacent to the Grimstone and Sortridge Leat.

CHAPTER THREE
Churches, Schools, Houses and Farms

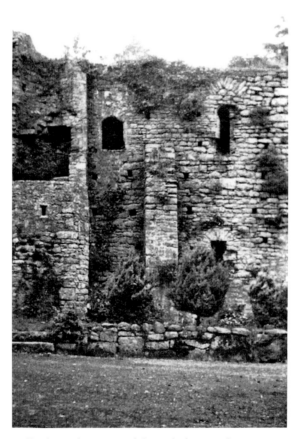

Gidleigh Castle, a view of the early fourteenth-century fortified manor house, of which only the ruined keep remains.

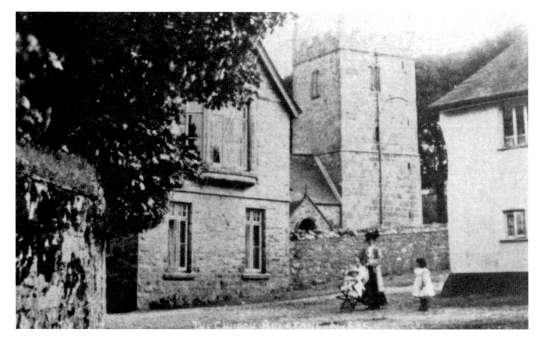

Although Belstone has had a church since the thirteenth century, the Church of St Mary the Virgin, about 1000 ft above sea level, is thought to be fourteenth or fifteenth century in origin. It was partially restored in the mid nineteenth century.

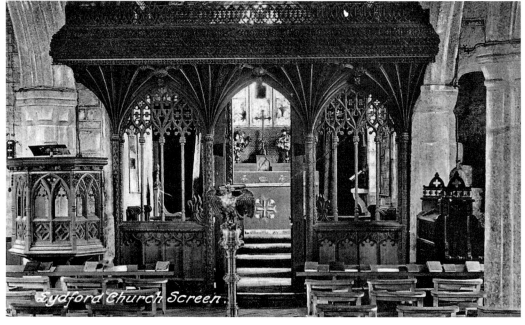

The screen at St Petrock's Church, Lydford. A timber church is believed to have been built on the site in the seventh century and burnt down by the Danes around 990 AD, the present church being rebuilt during the Norman era.

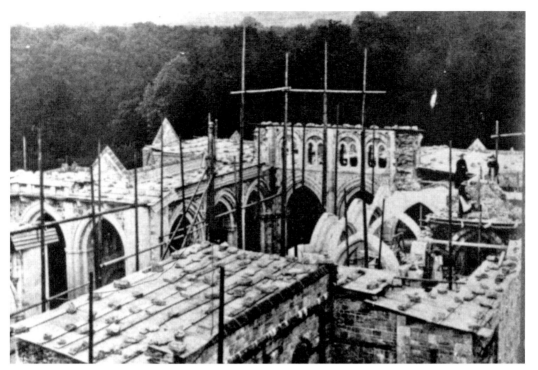

Buckfast Abbey forms part of an active Benedictine monastery at Buckfastleigh. Dedicated to St Mary and founded in 1018, it was run by the Cistercian order from 1147 until its destruction in the dissolution of the monasteries. Monks began living there again in 1882, and major restoration of the abbey was carried out between around 1905 and 1937. These two photographs show the abbey *c*. 1910 and during one phase of rebuilding in May 1913.

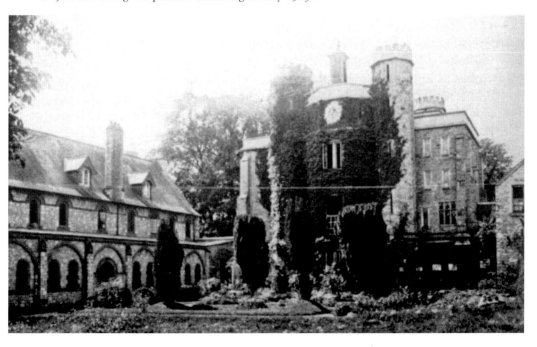

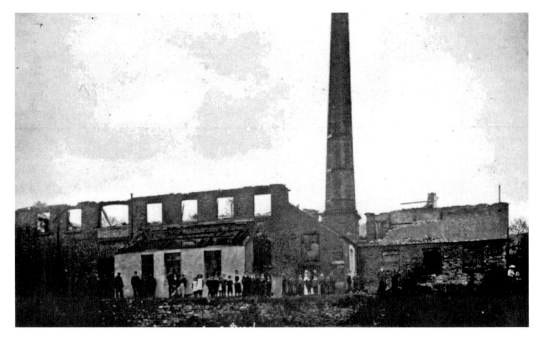

Churchwards Factory, Buckfastleigh, one of the town's old woollen mills powered by water from the Mardle, destroyed by fire in 1906.

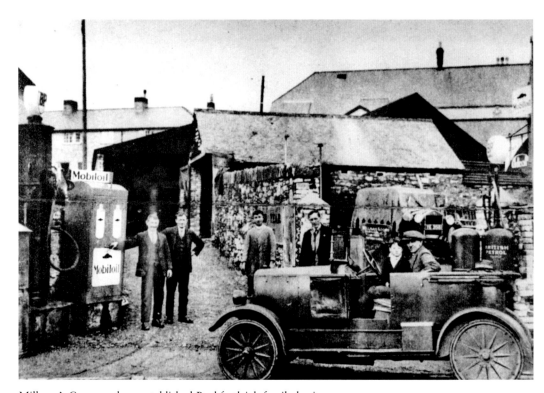

Millman's Garage, a long-established Buckfastleigh family business, *c.* 1910.

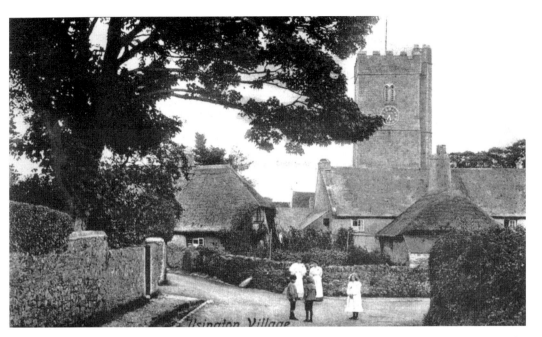

Two views of St Michael's Church, Ilsington. The first, *c.* 1900, shows the clock tower dominating the village centre, while the second, from a postcard published abut twenty years later, shows it from the other side. A church stood on this spot probably in Saxon times, but was largely rebuilt in the late fifteenth century. Although not visible here, there are ruins of the walls of the old manor house in the churchyard.

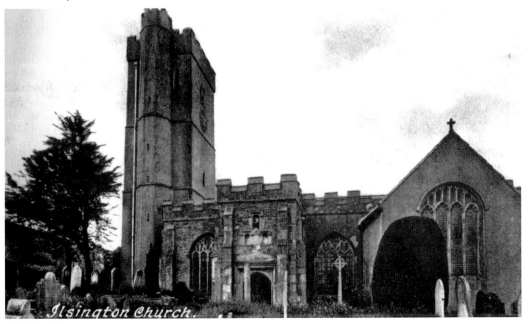

Honeywell Wesleyan Chapel, Ilsington, *c.* 1905. Before it was built in 1851 and opened the following year, the Methodist Minister, William Lambshead, held services in his kitchen at Honeywell Farm.

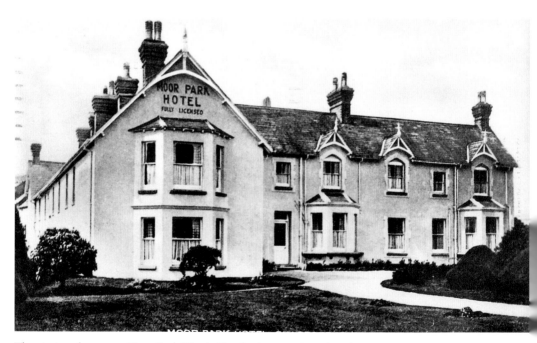

The nineteenth-century Moor Park Hotel, Chagford, now private housing.

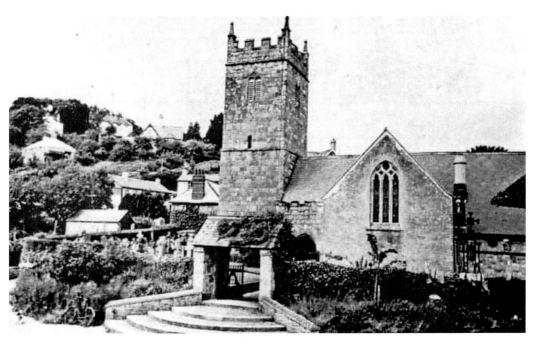

Church of St John the Baptist, Lustleigh. The first part, including the basic rectangle and south porch, was built around 1250, with the south chapel and tower added during the fourteenth century and the north aisle in the fifteenth century.

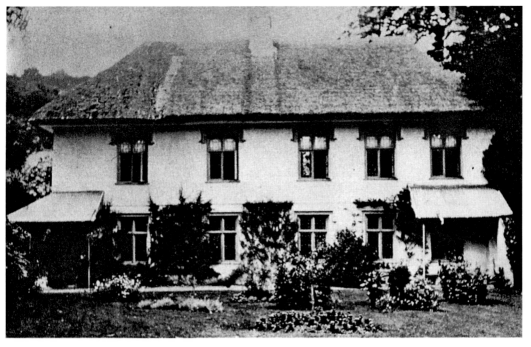

Holne vicarage, where author Charles Kingsley was born in 1819 while his father was curate-in-charge at the Church of St Mary the Virgin.

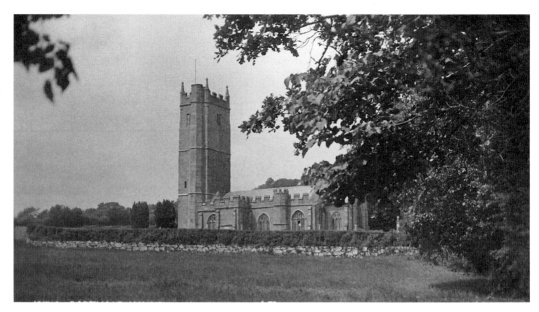

St Winifred's Church, Manaton, dating from the fifteenth century. In the churchyard is a granite cross, and according to tradition, whenever a coffin is carried in it must be walked thrice clockwise around the church.

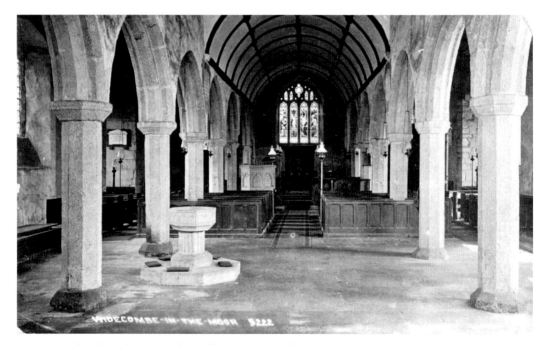

St Pancras Church, Widecombe, often called the 'cathedral of the moor'. Built in the fourteenth century and since enlarged, it was damaged in October 1638 when struck by lightning during afternoon service. Of 300 worshippers present, four were killed and about 60 injured when a pinnacle from the top of the tower fell into the church. According to legend, it happened as the village was being visited by the devil.

Brentmoor House, near South Brent, formerly owned by the Pritchard family, was later taken over by the Youth Hostel Association, then by South West Water during construction of the Avon Dam, before the vandalised remains were demolished in 1968. This picture was taken in the winter of 1934 by Mrs Kathleen Holman, the author's grandmother.

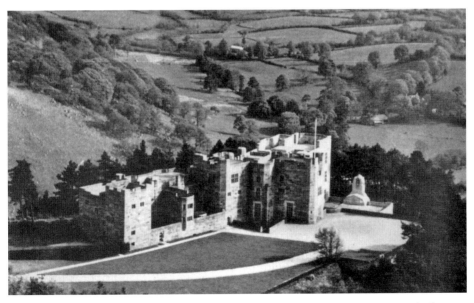

Castle Drogo, a country house near Drewsteignton, situated above Teign Gorge, was built by Edwin Lutyens and completed in 1930. It was the last castle to be built in England, and probably the last private house in the country built entirely of granite.

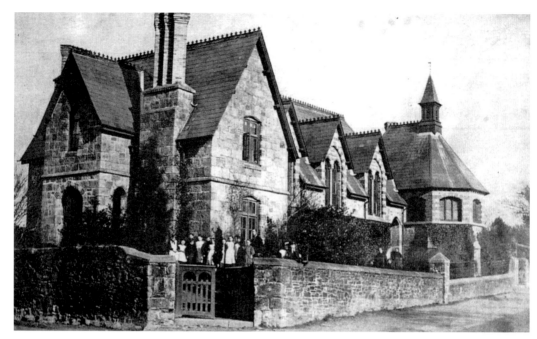

Cornwood School, *c.* 1890, built in 1859. The headmaster lived in the schoolhouse at the rear. Inscribed on the front are FIDELI CERTA MERCES (Reward is certain for him that keeps faith), NOS NOSTRAQUE DEO (We dedicate to God ourselves and all we have) and NEC PRAEDA NEC PRAEDO (I shall be neither robbed nor robber).

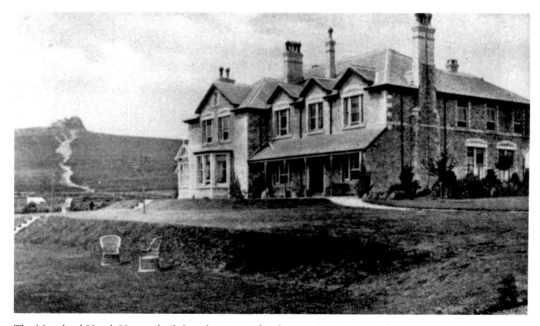

The Moorland Hotel, Haytor, built largely to cater for the growing tourist trade, was completed in 1902. Agatha Christie stayed there in 1916 while writing her first published novel, *The Mysterious Affair at Styles*.

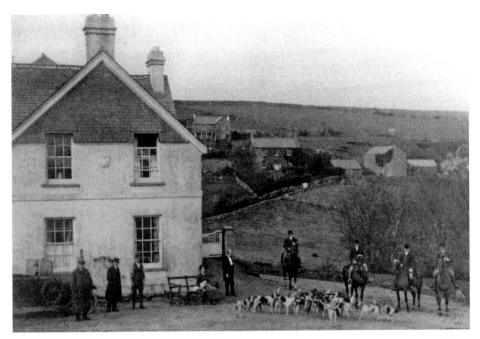

Hexworthy Forest Inn, *c.* 1920, was built in the mid nineteenth century. Severely damaged by fire in 1913 when the thatched roof was destroyed, it was rebuilt and opened again in 1916. According to Dartmoor writer William Crossing, from its door the spectator had 'far and away the finest view within the forest of Dartmoor'.

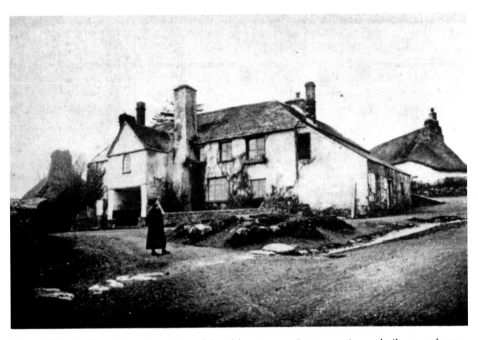

Holne, Church House Inn, 1892. One of the oldest inns on Dartmoor, it was built around 1329 by stonemasons who lived there while working on St Mary's Church nearby.

Little Silver Cottage near Manaton, which was demolished early in the twentieth century with stone subsequently used to build barns at Foxworthy.

Cottages at Lydford, which was recorded in Domesday Book as one of only five towns in Devon, built by the Saxons as a defence against Viking raids.

Elliott's Hotel, Mary Tavy, *c.* 1908,
which later became the Bullers Arms and
subsequently the Mary Tavy Inn.

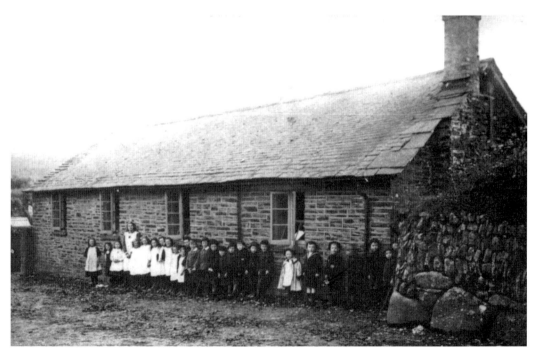

Meavy School, seen here in the late nineteenth century, was built on Great Palmers Meadow, opposite
Church Gate, and opened on 29 September 1837. When Sheepstor School closed in 1923, a new
combined school at the east end of Meavy village opened in January 1926.

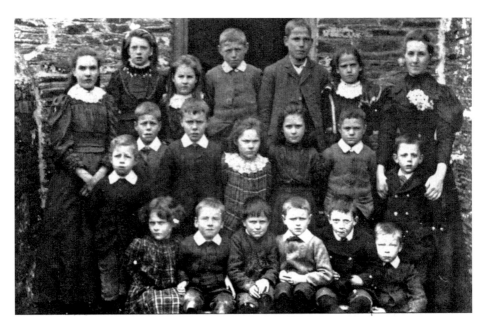

Meavy School and the children with Miss Christian Wilmot, their teacher, standing on the right, *c.* 1894.

The Royal Oak and Royal Oak Inn, Meavy, 1888, photographed by Robert Burnard, in foreground Arthur Sale and Charlie Glive. The early fifteenth-century inn is named after the oak tree on the village green. Originally owned by the church, it was formerly the Church House Inn.

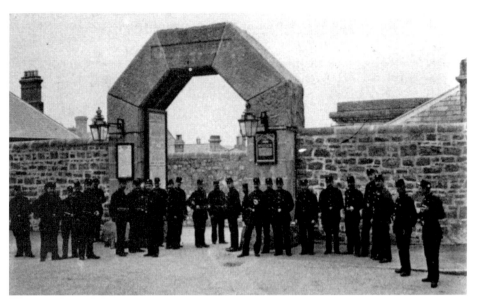

Princetown Prison, built between 1806 and 1809 to hold prisoners of the Napoleonic Wars, was also used in the early days to hold American prisoners from the war of 1812. Reopened as a civilian prison in 1851, it now holds mainly non-violent offenders and white-collar criminals.

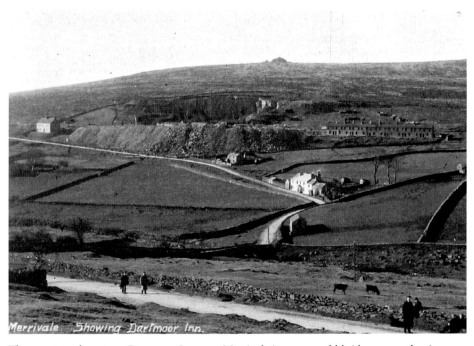

The seventeenth-century Dartmoor Inn near Merrivale is near an old bridge across the river Walkham, between Princetown and Tavistock, an old packhorse route across the moor. The Merrivale stone rows nearby are sometimes called the plagues market, as farmers left their produce there to be collected by people from plague-ridden Tavistock in 1625.

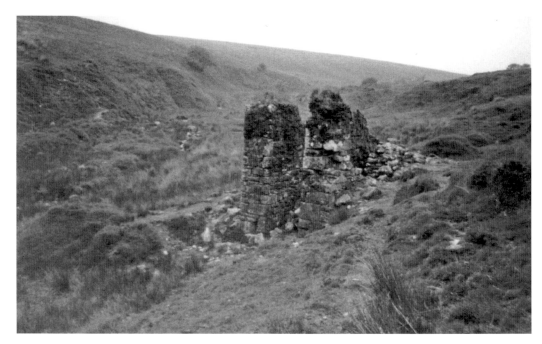

The remains of Middle Brook wheel house, with what is left of the winding gear for a mineshaft long since filled in. Middle Brook, on Brent Moor, is a tributary of Bala Brook, which joins the Avon near Shipley Bridge.

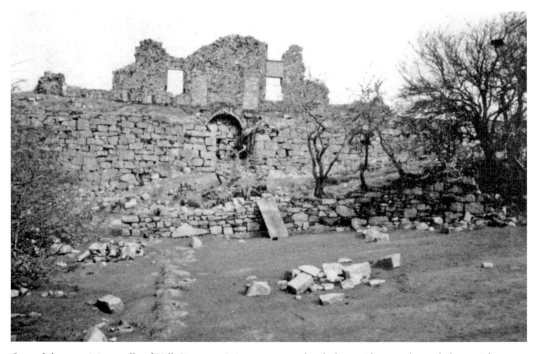

One of the remaining walls of Hill Cottages, Princetown, on the skyline with an archway below, with the remains of the quarry manager's house, largest of the Foggintor buildings, in the foreground.

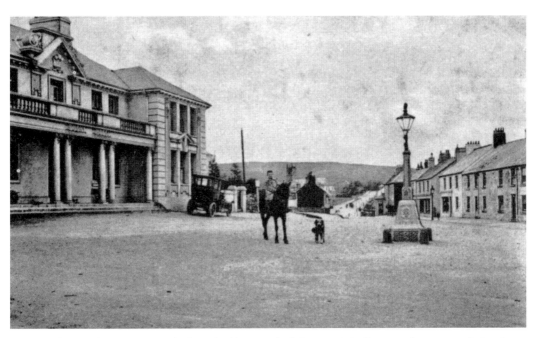

Duchy Hotel, Princetown. The large building on the left was originally erected as accomodation for the prison officers, and then acquired *c.* 1850 by James Rowe, who refurbished it and opened it as a hotel. Arthur Conan Doyle is believed to have stayed there in 1901 while writing *The Hound of the Baskervilles*. In 1941, it was taken over by the prison service for use as an officers' mess. It is now the site of the High Moorland Visitor Centre, opened by the Prince of Wales in 1993.

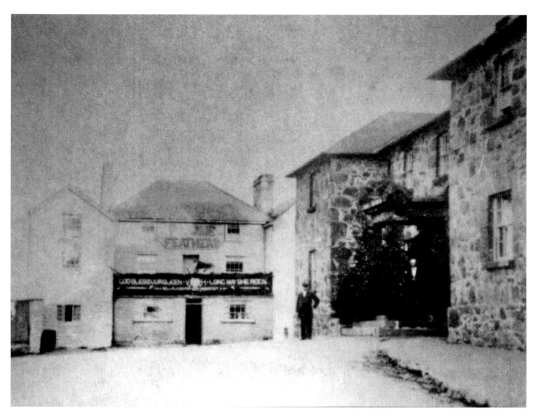

The Plume of Feathers, Princetown. Named after the Prince of Wales's insignia, it was originally built around 1785, to provide accommodation for the labourers working on what was then the new town, and is thus probably the oldest building of them all. The first view shows the exterior decorated for Queen Victoria's Jubilee in June 1887, while the second was taken *c.* 1910.

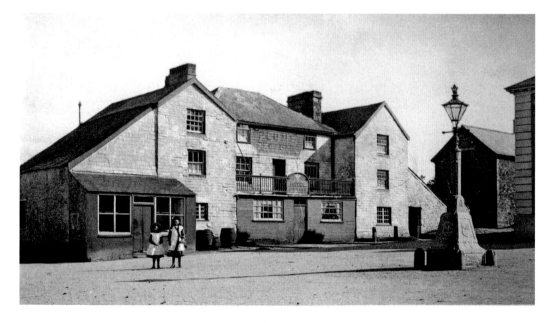

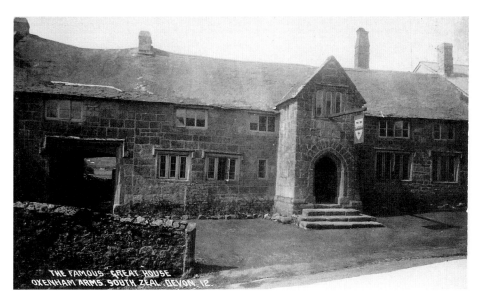

The Oxenham Arms, South Zeal, *c.* 1910. Still thriving today, this twelfth-century inn is one of the oldest in Devon, if not England. Built by lay monks, it later became the Dower House of the Burgoynes and then passed to the Oxenham family. John Oxenham, a close friend of Sir Francis Drake, was the first English captain to sail the Pacific, but was captured as a pirate and executed in Peru in 1580.

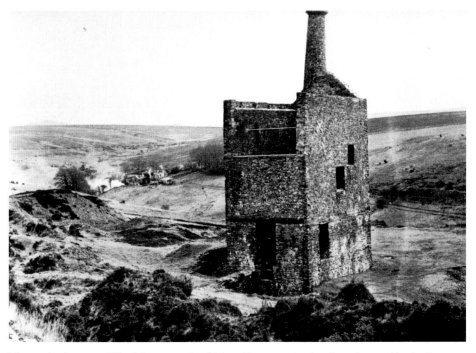

The engine house at Wheal Betsy, north of Mary Tavy, a major local producer of lead, silver and zinc, was built in 1868 but the mine closed in 1877. Its remaining structure was acquired by the National Trust in 1967.

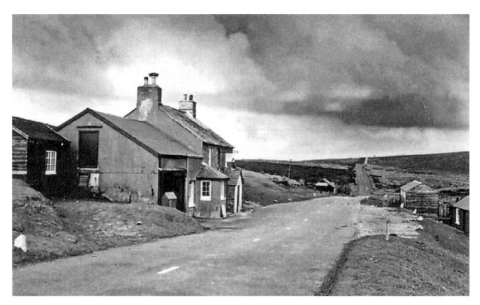

The Warren House Inn, between Princetown and Moretonhampstead. Originally built on the opposite side of the road around 1760, for years it was known as the 'New House', and later renamed after the nearby Headland Rabbit Warren. In 1845 the present premises were erected, and the peat fire lit in the hearth is said to have burned continuously ever since.

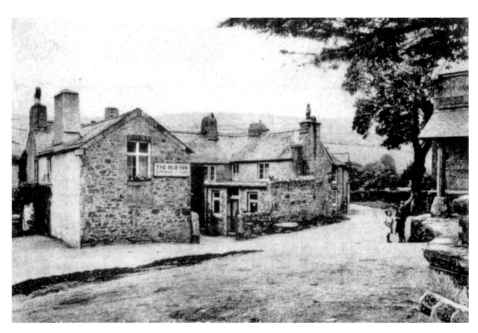

The Old Inn, Widecombe-on-the-Moor, shown here *c.* 1920, was built in the fourteenth century, and was at various times a magistrates' court and a stannary. It was severely damaged by fire in 1977 but later restored.

Addicombe, near Harford, a long abandoned farmhouse on edge of the moor close to the river Erme. Only a small part of the outer house is still standing.

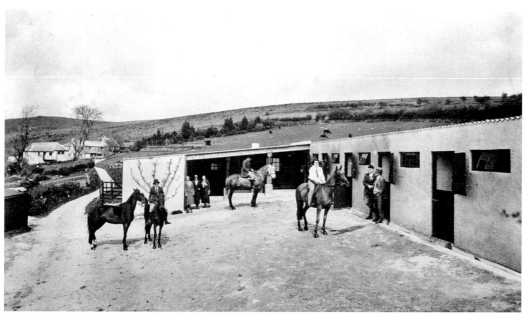

Bullaven, near Harford, seen here c. 1950, was formerly a farm and later became a private residence.

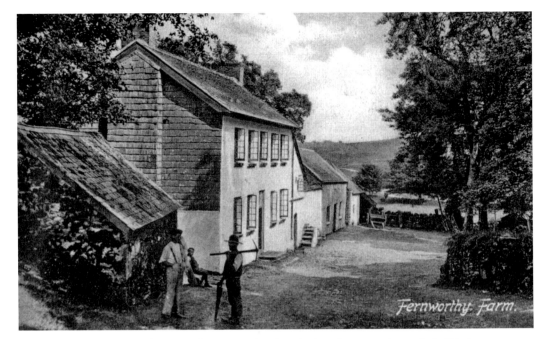

Fernworthy Farm in the early twentieth century, abandoned when the reservoir was built. Work started in 1936 but it was delayed by a severe thunderstorm in 1938 when the works became flooded, and then by the outbreak of war, and finally completed in 1942.

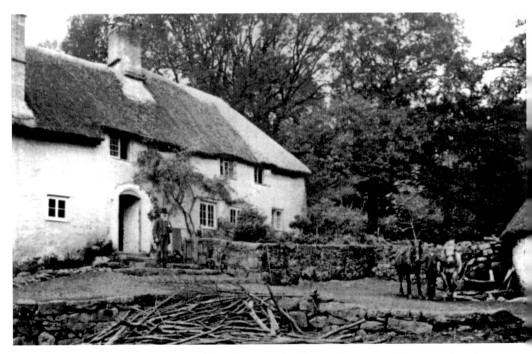

Ilsington, Pinchaford Farm, *c.* 1900. A fifteenth-century longhouse, it was gutted in 1944 when the thatched roof caught fire.

Kingsett Farm ruins, near Sheepstor. There was a farm on this site in the fourteenth century, but it was abandoned early in the twentieth century after Plymouth Corporation disallowed any livestock farming in the catchment area of Burrator Reservoir.

Manga Farm, originally a single-storey, three-roomed building built about 1808 near Fernworthy Forest, which lay in ruins some eighty years later.

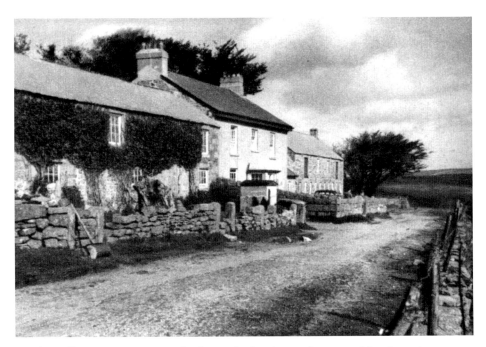

Powder Mills Farm was a gunpowder factory in the nineteenth century. After dynamite was invented, demand for gunpowder fell, and the mills closed in 1897. Some of the buildings were used to accommodate cattle, and in World War Two the site was occupied by American soldiers as a training camp for the D-Day landings. The mill is now a ruin.

Crockern Farm, near Princetown, *c.* 1930, one of the main centres for the extraction of peat from naphtha in the nineteenth century.

The Ockery, on the banks of the Blackabrook near Two Bridges Road. Built *c.* 1805 in the then fashionable 'Swiss style', it was a small square three-storey thatched building with granite walls. Two French generals are thought to have lived or stayed here during the Napoleonic wars. A widowed tenant poisoned herself there in 1914 after being told she was under suspicion of stealing pigs from a neighbouring farmer, and it was demolished in 1925, but the barn has since been repaired and is now used as a stable.

Beardown Farm (or 'Bair Down', from 'bearo', a grove or wood) near Two Bridges, *c.* 1910, where religious services were regularly held in the nineteenth century.

Towns, Villages and Hamlets

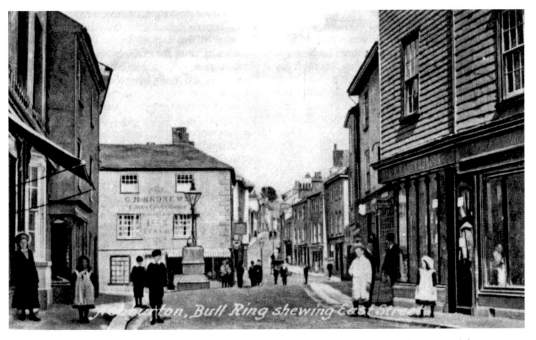

Ashburton Bull Ring and East Street. The centre of town is known as the Bull Ring, and fences were placed along the pavement where the cattle would be gathered for sale on market days.

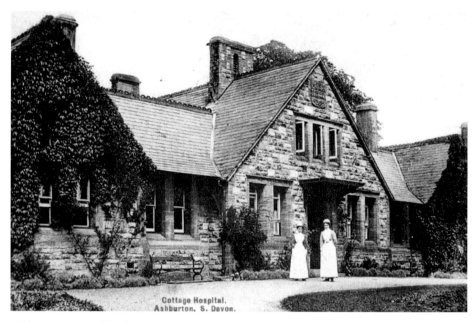

Ashburton and Buckfastleigh Cottage Hospital, Eastern Road, *c.* 1915. Opened in 1889 by Lord Clinton, Lord Lieutenant of Devon, it has regularly been upgraded and extended in recent years.

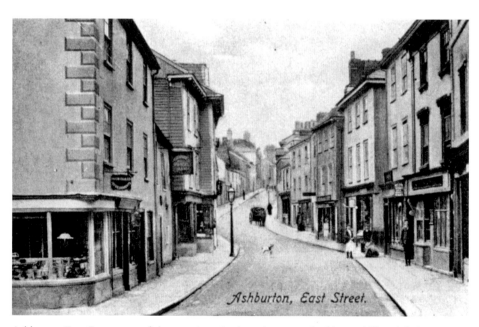

Ashburton East Street, one of the town's main shopping areas, looking uphill and facing eastwards, early in the twentieth century.

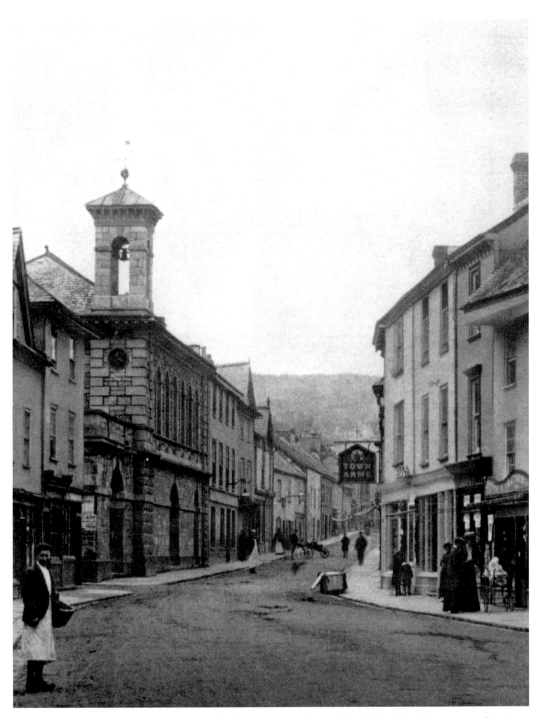

Ashburton, North Street, *c.* 1905, with the granite Market Hall on the left, built in 1850, and a sign for the Town Arms prominent on the right.

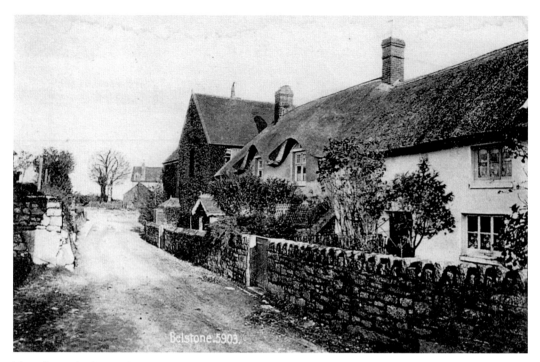

The village of Belstone, listed as Bellestam in Domesday Book. The name is thought to have been derived from Belle's Ham (Belle's enclosure), or Belle Stan (Bell's Rock).

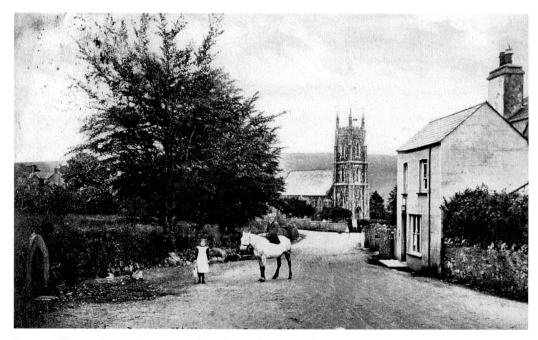

Brentor village and post office, 1908, about four miles north of Tavistock. The nineteenth-century cottages provided accommodation for the village shops, post office and bakery; the last shop and post office closed in the 1980s.

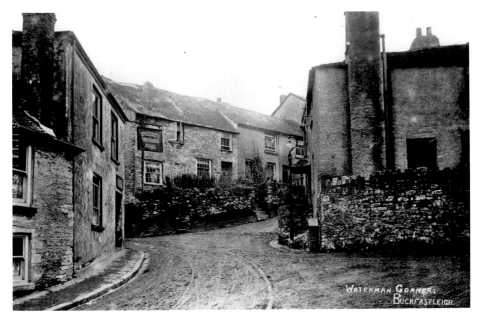

Waterman Corner and the Waterman's Arms, one of the few Buckfastleigh inns surviving into the twenty-first century.

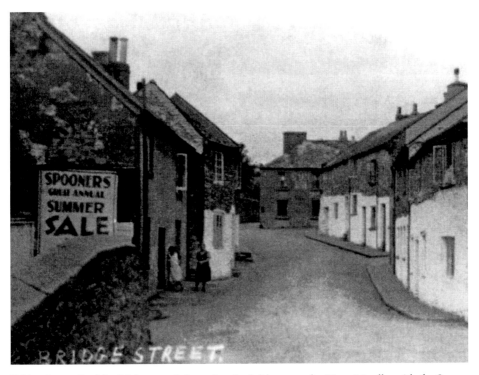

Bridge Street, Buckfastleigh, named thus after the bridge over the River Mardle, with the Sun Inn at the end on the right.

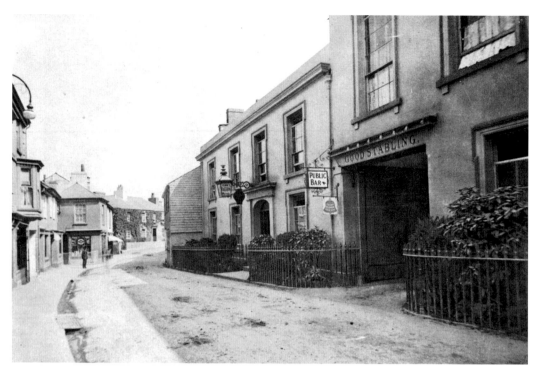

Fore Street, Buckfastleigh, *c.* 1910, facing east. The railings in front of the houses on the right were removed to help the war effort in 1940.

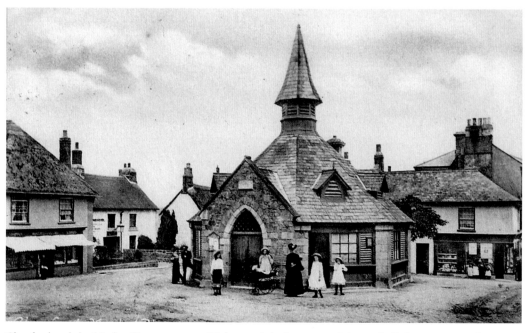

Chagford and the Market House, *c.* 1910. Nicknamed the 'pepper pot', it was built in 1862, one of several improvements to the town sponsored by the Revd Hayter George Hames.

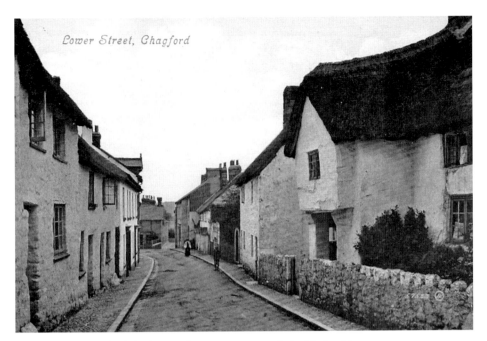

Lower Street, Chagford, leading to the town square and the Market House.

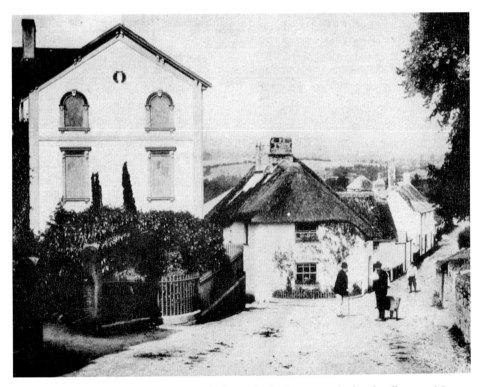

Mill Street, Chagford, c. 1900, showing the house built about 1820 by local mill owner Mr Berry which has since become the Moorlands Hotel.

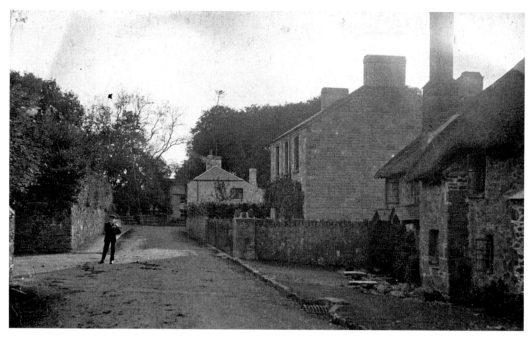

The centre of Cornwood, a village in the Yealm valley on the south-western boundary of the moor, *c.* 1920.

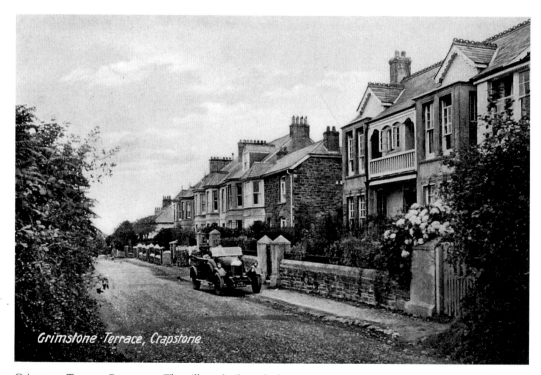

Grimstone Terrace, Crapstone

Grimstone Terrace, Crapstone. The village, built in the late nineteenth century, is named after the old manor house, Crapstone Barton.

Drewsteignton, *c*. 1890, with several groups of people in the old village square adjoining the fifteenth-century Church of the Holy Trinity.

The Druid's Arms, Drewsteignton Square, *c*. 1910, later renamed Drewe Arms after Julius Drewe. Mabel Mudge came to the pub in 1919 as landlady and after her husband's death in 1971 ran it till she retired in 1994, aged ninety-nine.

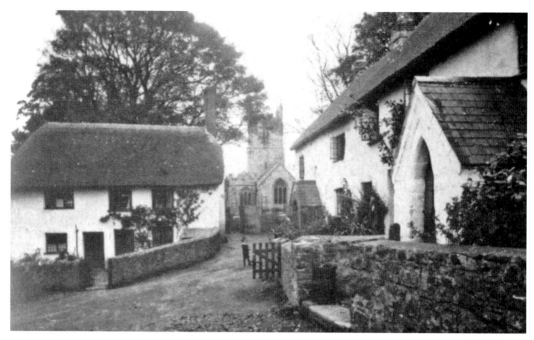

Drewsteignton Church Gate, *c.* 1910. The churchyard has a granite memorial to Julius Drewe, who commissioned Castle Drogo, designed appropriately by his architect Edwin Lutyens.

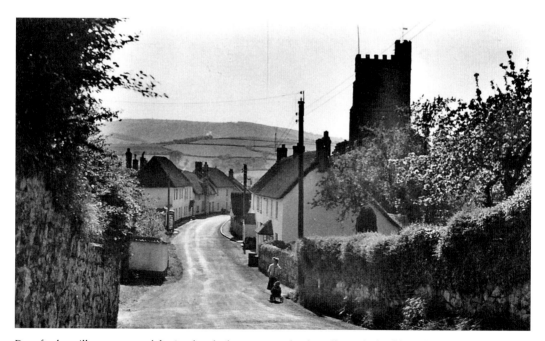

Dunsford, a village renowned for its thatched cottages and cob walls, with the fifteenth-century St Mary's Church on the right.

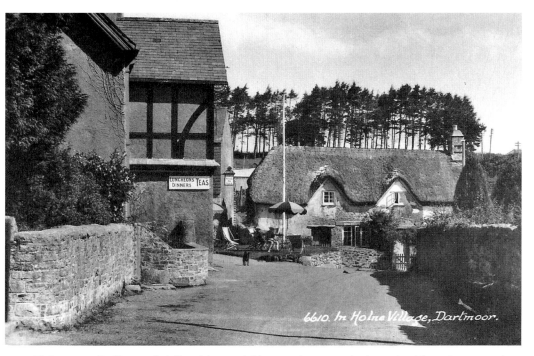

Holne, a small village and civil parish near Ashburton. A community has existed here since around the eleventh century.

Moretonhampstead Convalescent Home, seen here in the 1950s, closed about twenty years later, and has since become a hotel.

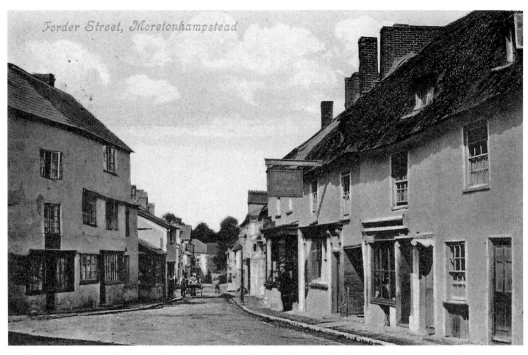

Forder Street, Moretonhampstead, *c.* 1905, which shortly afterwards changed its name to Ford Street.

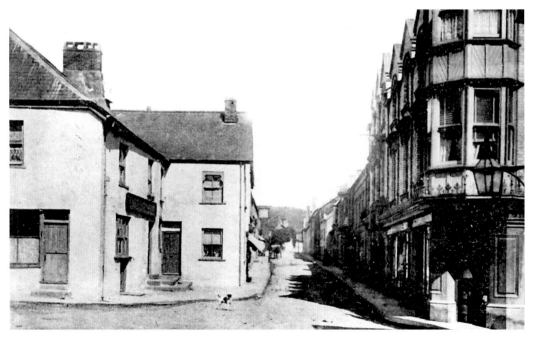

Cross Street, Moretonhampstead, *c.* 1902, renowned for its row of Jacobean-style almshouses built in the seventeenth century.

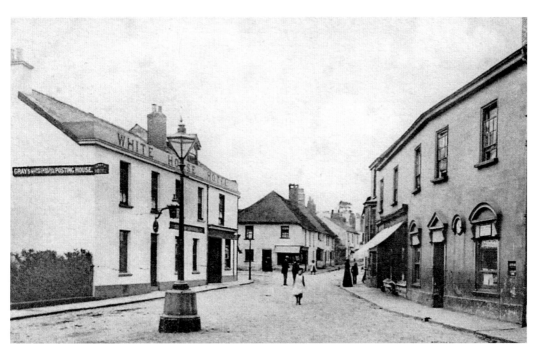

New Street, Moretonhampstead, *c.* 1920, dominated by the White Horse Hotel, formerly Gray's Hotel and now the White Horse Inn.

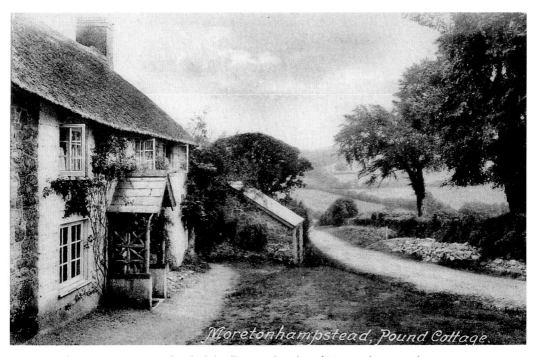

Pound Cottage, *c.* 1905, a thatched dwelling on the edge of Moretonhampstead.

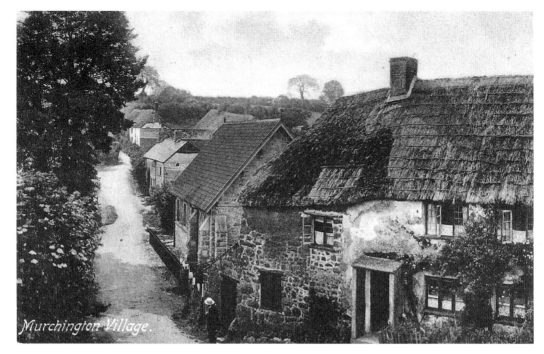

Murchington, a hamlet one mile north-west of Chagford. The Victorian chapel has since been converted into a holiday home.

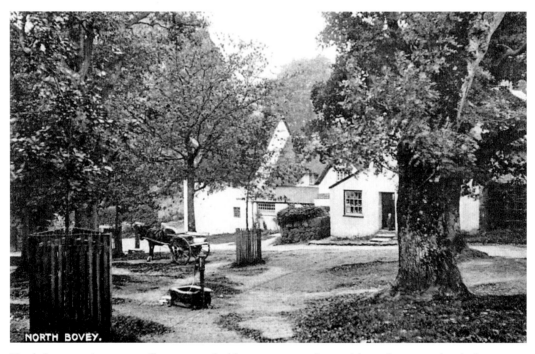

North Bovey, a picturesque village approached by steep narrow lanes, eighteenth-century thatched cottages surrounding a village green with stone cross and pump.

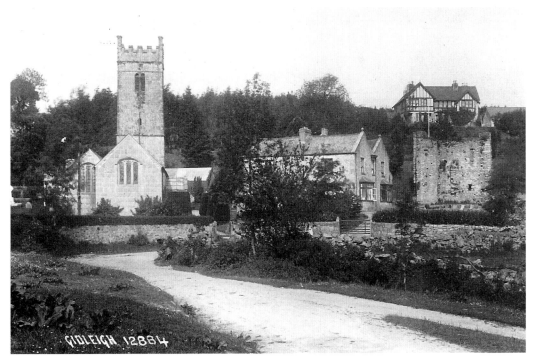

Gidleigh, a small village with the fifteenth-century Church of the Holy Trinity on the left.

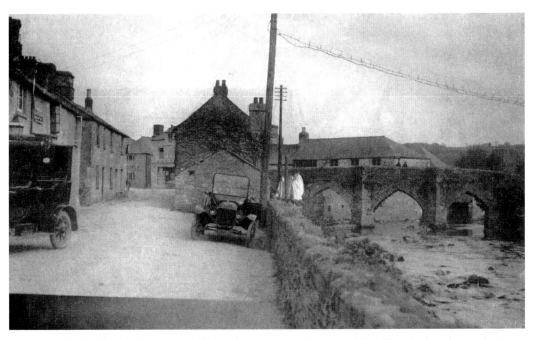

Horrabridge, beside the River Walkham, from a postcard c. 1915. The village is thought to take its name from the fifteenth-century packhorse bridge, and the cottages in the centre were demolished about 1970.

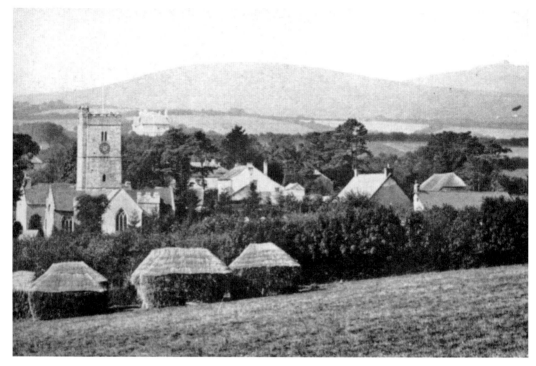

Ilsington, Jubilee Field, *c.* 1905, where South Parks now stands. The slopes of Pinchaford Ball and Haytor Rocks can be seen on the skyline.

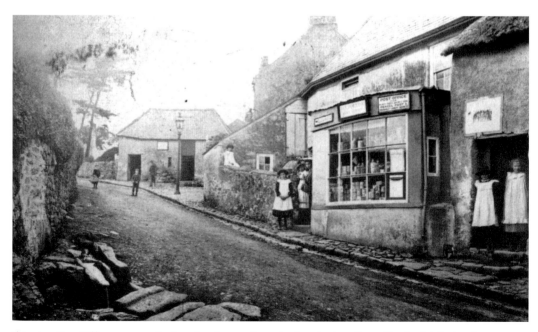

Ilsington Post Office, *c.* 1900. At that time it was the only shop in the village. On the left is the shute for collecting the local water supply, which ran down from Haytor in an open gutter.

Lustleigh village centre, *c.* 1920. Lustleigh is one of the oldest villages on Dartmoor, with Bronze Age hut circles and an Iron Age fort within the parish boundaries, and records in Domesday Book of the villagers producing honey.

Manaton Green, *c.* 1930. The village is based around the church of St Winifred, and was once the home of writer John Galsworthy.

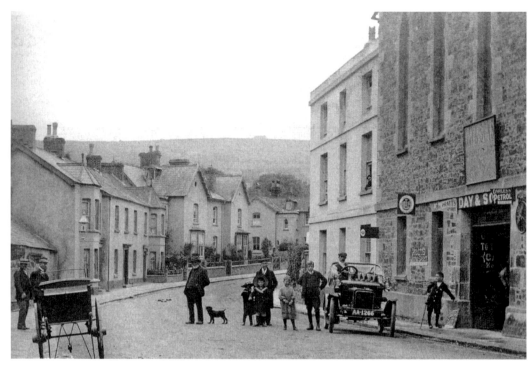

New Road, Okehampton, the main road from the town (and the county) into Cornwall, *c.* 1900.

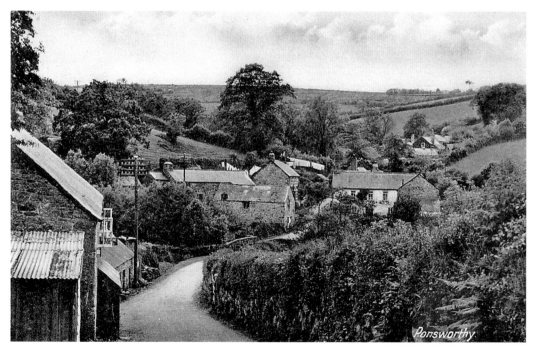

Ponsworthy, a hamlet in the valley of the East Webburn, about two miles south-west of Widecombe, lying on the medieval packhorse route from Tavistock to Bovey Tracey.

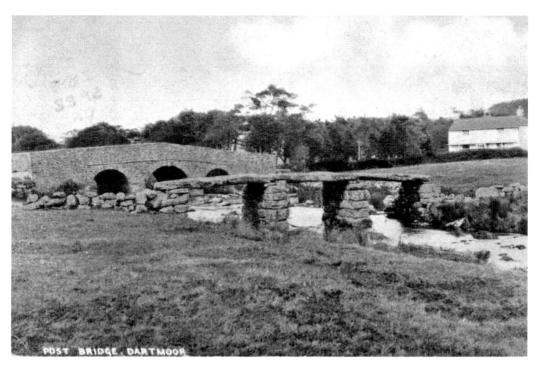

Postbridge is a small village at the heart of the national park, with what is considered the finest clapper bridge in Devon, built around 1780, straddling the East Dart.

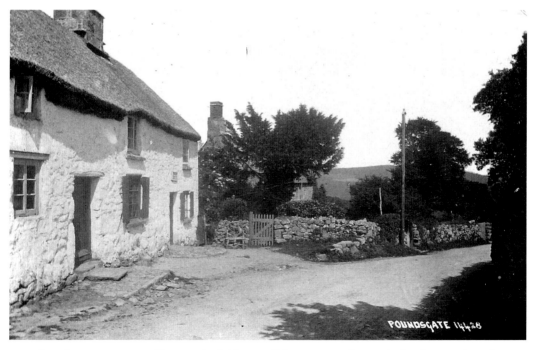

Poundsgate, *c.* 1915, a village on the Ashburton–Princetown road, named after the pound nearby.

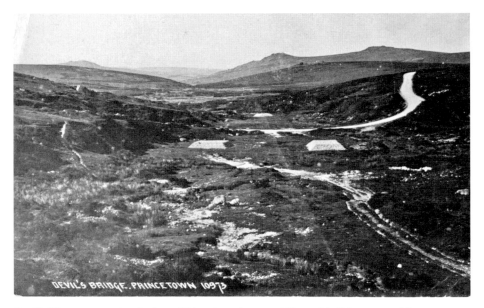

Devil's Elbow, a notoriously sharp 'S' bend on the steep hill outside Princetown. After a spate of car accidents, the road was modified to make it safer for traffic. The name lives on, as a Princetown pub and as a local folk group.

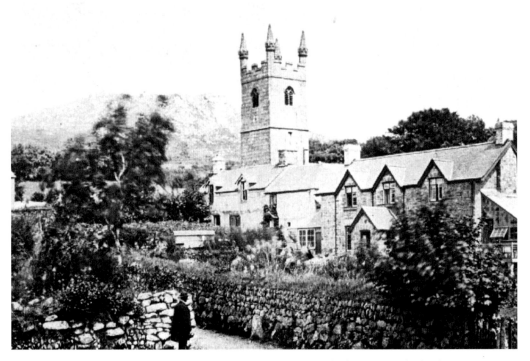

Sheepstor village and St Leonard's Church, on the eastern end of the village, built of granite in the fifteenth century, is the burial place of James, Charles and Charles Vyner Brooke, the three White Rajahs of Sarawak.

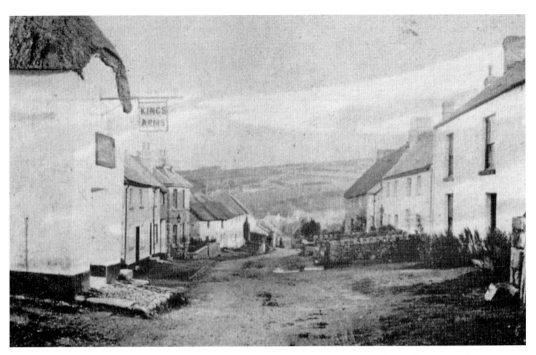

South Zeal in the late nineteenth century, with the Kings Arms on the left. Zeal was once known as Irishman's town, because of the large number of Irishmen working in the nearby mines.

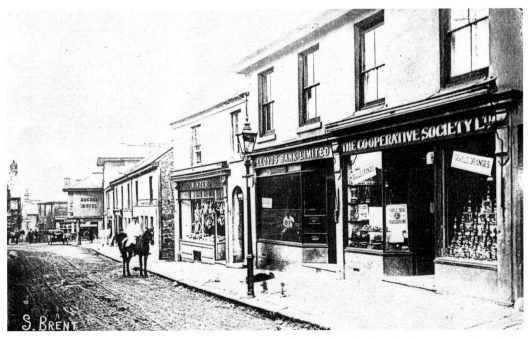

Station Road, South Brent, *c.* 1910. The street layout has barely altered in the last century, though all the shops and business premises except Lloyds Bank have long since changed hands.

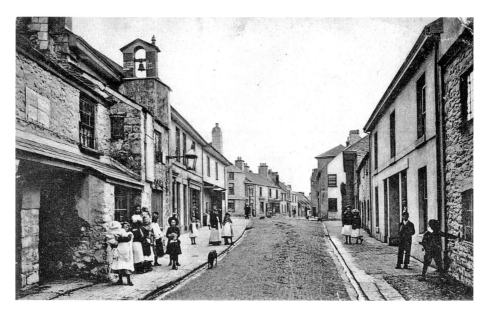

Two views of Church Street, South Brent. The first looks south towards the village centre, *c.* 1900, with the old tollhouse and bell tower on the left. The second, facing the other direction, was taken after a fire in February 1901 in which four houses were gutted though no lives were lost. The press remarked afterwards that 'Nero fiddled while Rome was burning. And the Parish Council fiddled about while Brent was burning, trying to find the key of the fire-engine house, trying to get the two-penny half-penny engine to work that Noah took with him in the Ark to water the plants in the window, trying to find which hole in the hose the most water would come out of.'

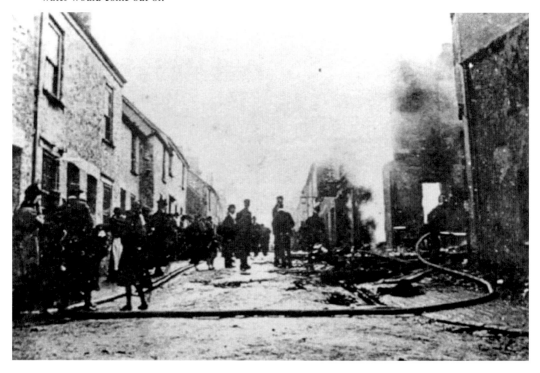

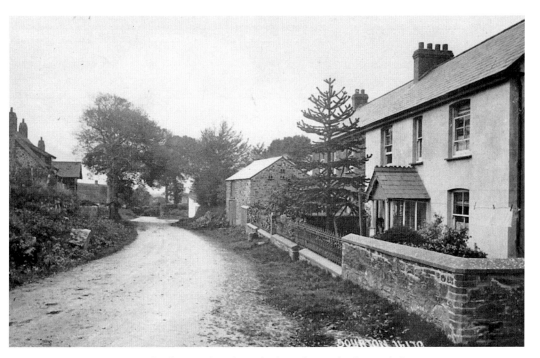

Sourton, *c.* 1914, a small village and civil parish about four miles from Okehampton. Sourton Down, to the north, was the scene of a battle in April 1643 during the civil war, resulting in defeat for the Royalist army.

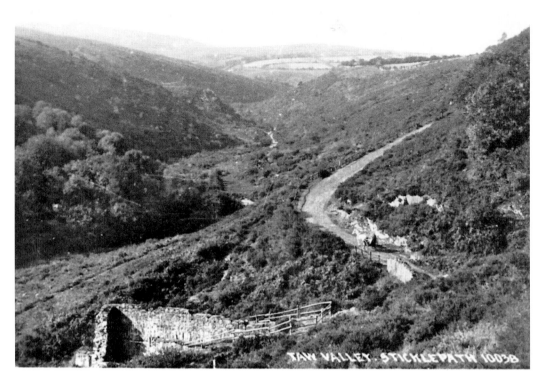

Sticklepath and the Taw Valley. The village of Sticklepath, from the Saxon 'staecle', or steep, lies at the point where the Taw crosses the old ridgeway path between Exeter and Launceston and where it was crossed by the old Mariner's Way, a route taken by sailors from Dartmouth to catch the boat at Bideford.

CHAPTER FIVE
Railways and Transport

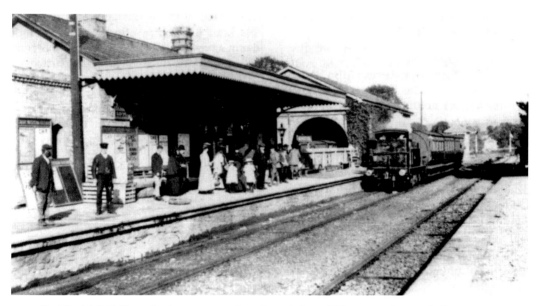

Buckfastleigh Railway Station *c.* 1905, a busy branch line which was used not only for passenger traffic but also to carry wool for mills, skins for the town tanning yard, racehorses and grooms for the local races. Passenger traffic ceased in 1958, and goods trains in 1962.

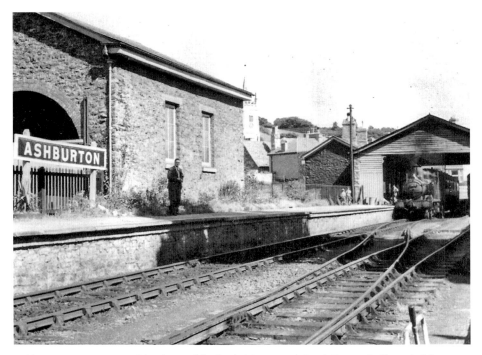

Ashburton Station, opened by the Buckfastleigh, Totnes and South Devon Railway in May 1872. It closed to passengers in November 1958, but goods traffic on the line continued until September 1962.

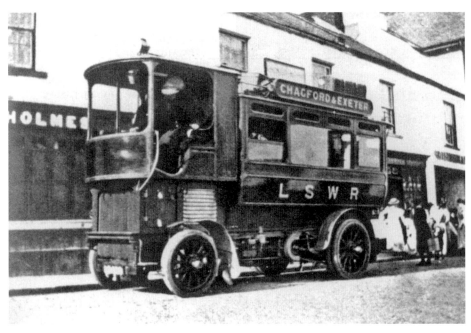

The LSWR (London and South Western Railway) steam coach in Chagford, *c.* 1920. Having no railway, the town needed to rely on alternative forms of transport.

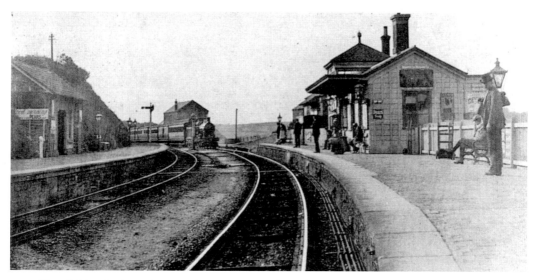

Horrabridge Station, a junction from Princetown branch from 1883 to 1885, when the Yelverton station opened. This picture shows the Plymouth-bound train.

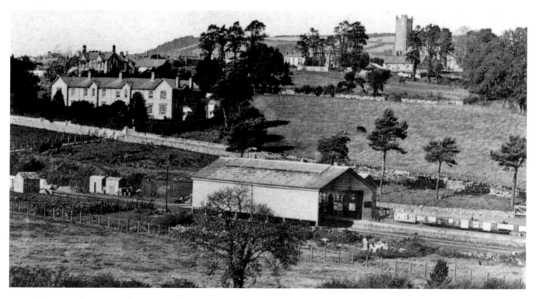

Moretonhampstead Station, the terminus of the Moretonhampstead and South Devon Railway, was opened in June 1866. It was closed to passengers in February 1959, although British Railways still used it as a base for roads goods services until 1964.

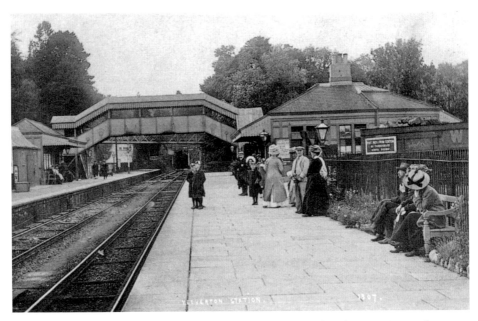

Yelverton, Station *c.*1920, which opened in May 1885 and closed at the same time as the Tavistock line on 31 December 1962.

William Alfred Kellaway, maternal grandfather of Dartmoor author Pauline Hemery (now Pauline Hamilton-Leggett) at the Manor Hotel, Dousland, 1898, was coachman for the Calmady-Hamlyn family, who lived near Horrabridge.

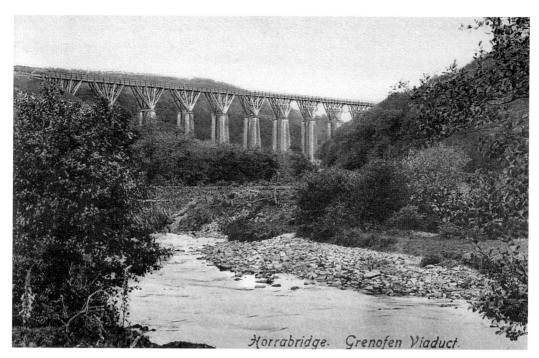

The Grenofen viaduct over the Walkham carried the railway between Horrabridge and Tavistock. It was demolished by explosives as a training exercise in 1965.

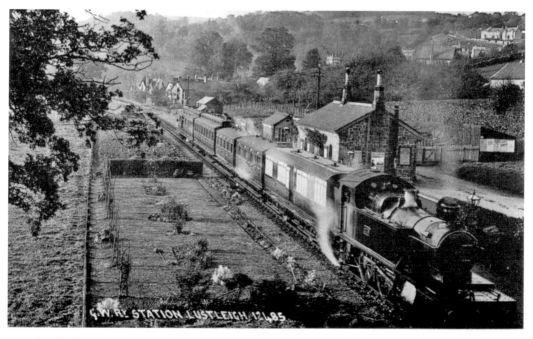

Lustleigh Station, *c.* 1910, one stop from Moretonhampstead. It opened in 1886 and closed in 1964. In 1931 it was used as the station in a film version of *The Hound of the Baskervilles*. The station building is now a private residence.

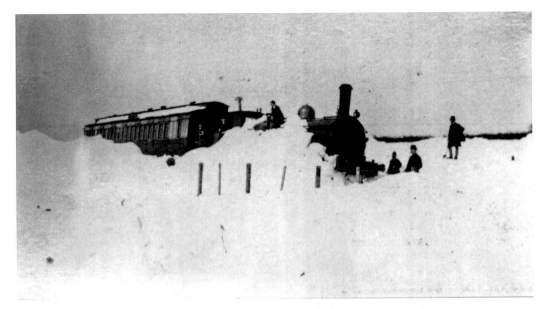

A train in a snowdrift, near Princetown, March 1891. It had left the town on 9 March at 6.34 p.m., but six passengers remained stranded until the morning of 11 March.

A train negotiating sharp bends around Kings Tor, near Princetown, a picture taken from near Walkhampton Foggintor School.

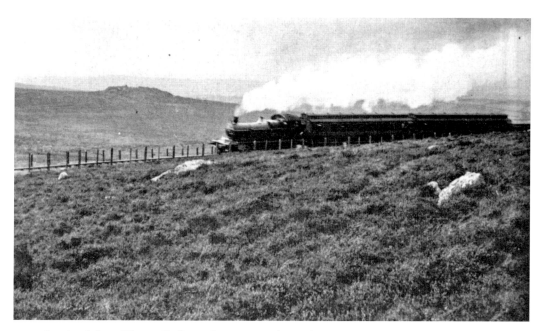

A train of Great Western Railway clerestory coaches with Ingra Tor near Princetown in the distance, early twentieth century. Ingra Tor halt was demolished in December 1956, and the only remaining relics are a concrete base and a couple of wooden sleepers.

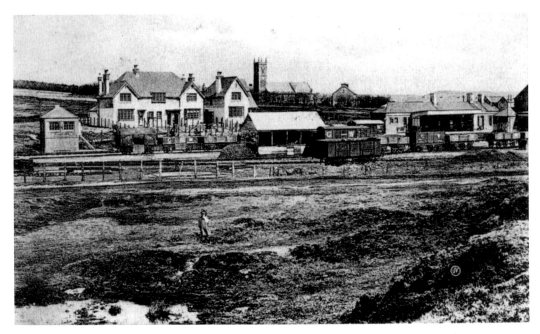

Princetown Station, part of the South Devon and Tavistock line, opened in August 1883, with trains running to and from Horrabridge Station on the South Devon & Tavistock line until May 1885 when Yelverton Station was opened. Princetown became part of the Great Western Railway network in 1922, passed to British Railways (Western Region) in 1948, and closed in March 1956.

CHAPTER SIX
People and the Military

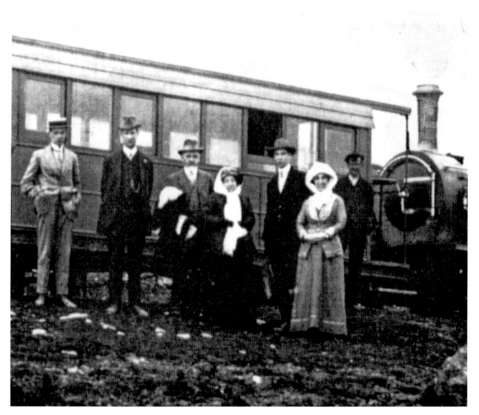

The opening of the Redlake Tramway, 11 September 1911. This group includes Mr and Mrs R. Hansford Worth, third right mine captain George Bray, and on the right Mrs Bray, who ran the clayworkers' hostel. The tramway took workers and materials to the quart while the china clay was piped with water to the Redlake works between Bittaford and Ivybridge.

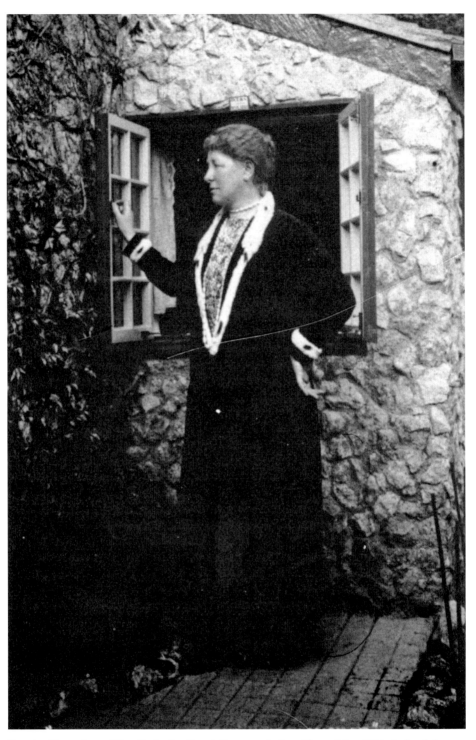

Beatrice Chase, born Olive Catherine Parr (1874-1955), the self-proclaimed 'My lady of the moor' a prolific author on Dartmoor subjects, and vigorous campaigner for the preservation of its natural environment.

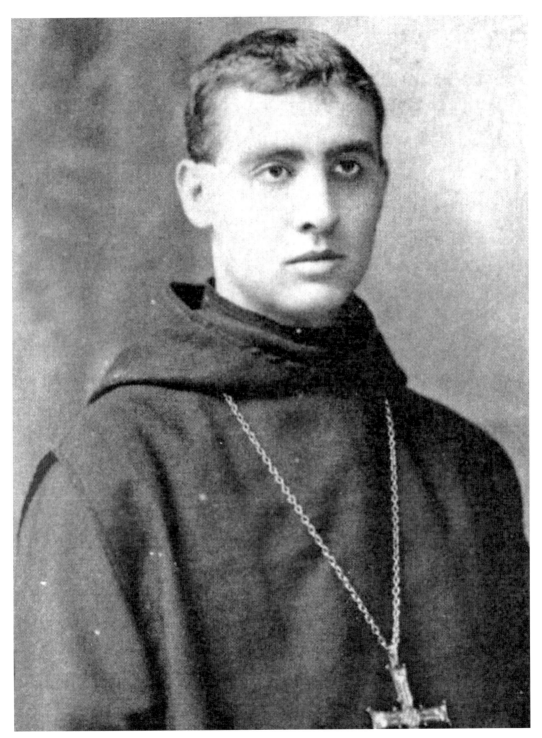

Father Vonier, shortly after his election as a very young Abbot of Buckfast in 1906; he was aged only about thirty at the time. During the next few years he oversaw the rebuilding of an Abbey Church at Buckfast on the twelfth century foundations.

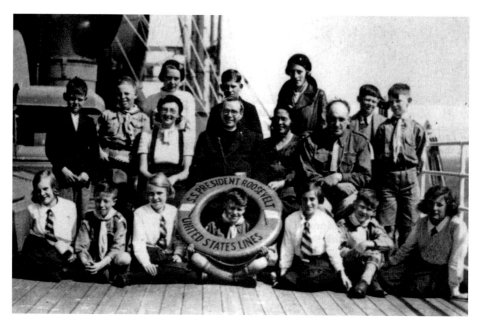

A group of Buckfast schoolchildren, 1 August 1935, on board the SS *President Roosevelt* en route for France, with the parish priest Father John Stephan seated in the centre.

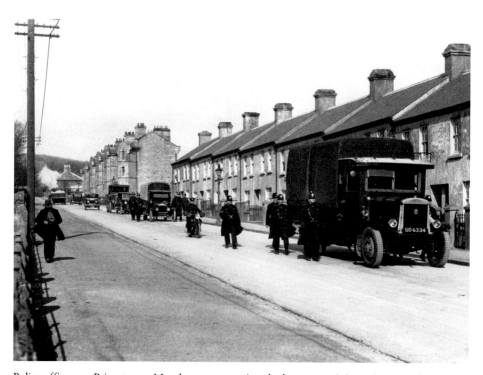

Police officers at Princetown, March 1932, escorting the lorry containing prison convicts on their way to the Duchy Hall for the assizes after a riot during which £3,000 worth of fire damage was caused, with forty-one inmates and twenty-four staff injured.

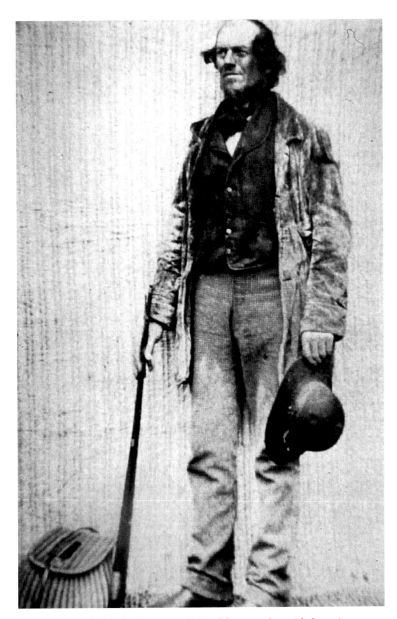

James Perrot of Chagford (1815-95). For fifty years he guided tourists over Dartmoor, and in 1854 he built a cairn at Cranmere Pool, placing a bottle inside where visitors could leave their calling cards. The later addition of a visitor's book was the start of the hobby of Dartmoor letterboxing.

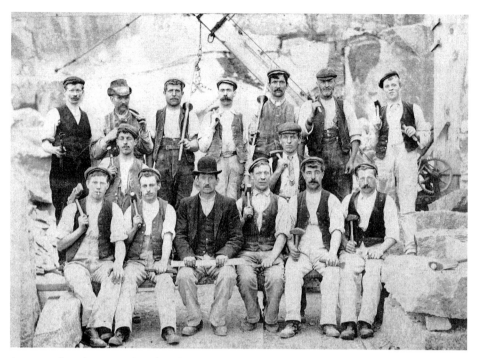

A group of workmen employed in the building of Castle Drogo near Drewsteignton, completed in 1930.

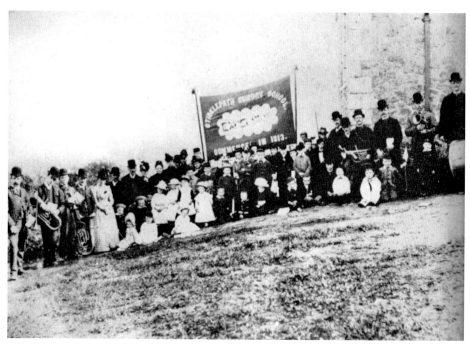

The Sticklepath Village Band, *c.* 1890, photographed outside the Sticklepath Board School. It used to accompany the local Sunday schoolchildren on their anniversary day.

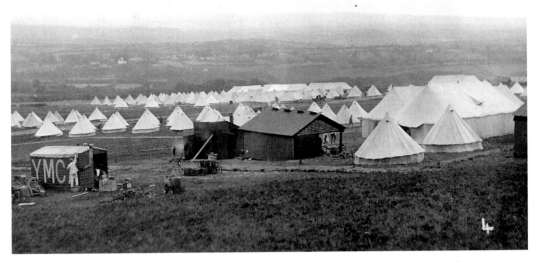

Okehampton, Willsworthy Camp, *c.* 1910. 3,448 acres of land and the commoners' rights were purchased by the War Office from the Calmady family, owners of Willsworthy Manor, around 1900, to provide accommodation for military encampments and firing practice.

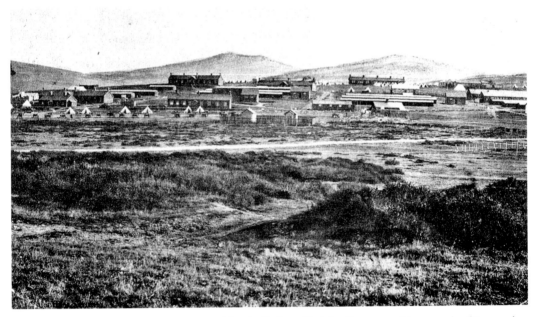

Okehampton Camp, *c.* 1900, managed by the Defence Training Estate, used by several military and cadet training units, and a base for the Ten Tors event run annually by the army. An artillery camp was established here about 1875.

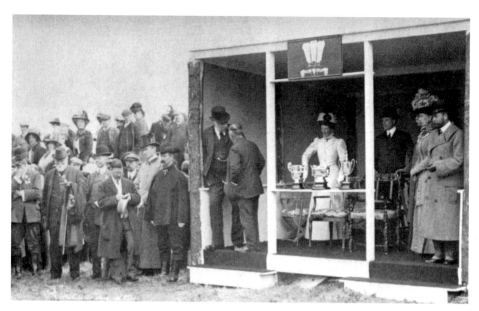

The Prince and Princess of Wales, later King George V and Queen Mary, attending Huccaby races in June 1909. Dartmoor photographer Robert Burnard is on the far left of the pavilion with his back to the camera for once.

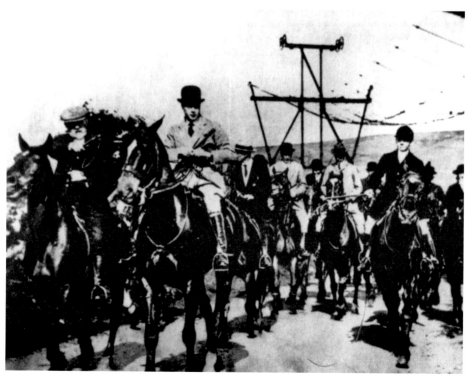

The Prince of Wales riding near Princetown, probably at a drag hunt with the Lamerton Hunt, starting from the Duchy Hotel, on the road from Whitworks to Tor Royal, 19 May 1921.

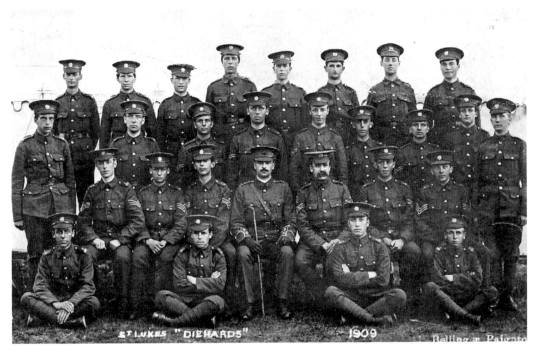

St Luke's 'Diehards', a group of soldiers stationed at Whitchurch. This postcard, postmarked 15 October 1909 to the writer's schoolboy cousin, includes in the message on the reverse, 'This is a photograph I had taken when I was at Camp. I wonder if you can find me.'

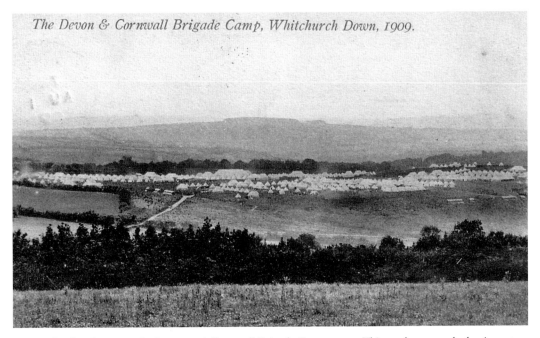

Whitchurch Down, the Devon and Cornwall Brigade Camp, 1909. This card, postmarked 1 August 1909, has the brief message, 'This is a view of the Camp. Splendid Place. Your Loving Pater'.

Acknowledgements

My greatest thanks in compiling this book are due to Paul Rendell, who generously allowed me to use a substantial number of pictures from his collection for this book. I am also grateful to Jan and Ossie Palmer, Pauline Hamilton-Leggett, Hilary Beard, Chris Routley, Greg Wall, Simon Dell MBE, QCB, Tony Barber, and Jamie Dunbar and the Dartmoor Archives, for also providing illustrations and general advice. As ever, I am eternally grateful to my wife Kim for her constant encouragement and support, and to Sarah Flight, my editor. Finally, this book is respectfully dedicated to my late mother Kate, a lifelong lover of Dartmoor, who would have been so proud to see this book and would have loved to see a number of photographs from the family albums on these pages.

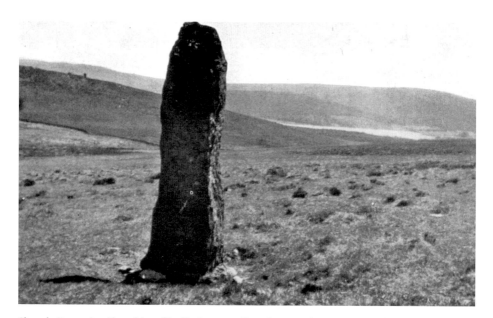

Shuggle Down (or Shoveldon, Shuffledown or Shovel Down) longstone, overlooking Fernworthy reservoir. One of the tallest menhirs on the moor, it probably dates from the Bronze Age.